Leonard Cohen

Leonard Cohen

almost young

An Illustrated Biography
Text by Jens Sparschuh

SCHIRMER / MOSEL

The Photographers

Jack Abuin

Carlos Alvarez

Bernard Barbereau

Allan Blackham

David Boswell

James Burke

Ian Cook

Hans-Jürgen Dibbert

Deborah Feingold

David Gahr

Gijsbert Hanekroot

Rune Hellestad

Ethan Hill

Tom Hill

Frédéric Huijbregts

Mitch Jenkins

Kevin Kane

Roz Kelly

Allan R. Leishman

Guy Le Querrec

Michael Loccisano

Terry Lott

Luke MacGregor

Nicolas Maeterlinck

Gary Miller

Oliver Morris

Tim Mosenfelder

Gary Moss

Sibylle Nottebohm

Michael Ochs

Thierry Orban

Eric Preau

Neal Preston

Michael Putland

Jack Robinson

Thomas Samson

Tom Sheehan

Ben Stansall

Gus Stewart

Alex Sturrock

Tony Vaccaro

Rob Verhorst

David Wolff-Patrick

Thanks to Michaela Angermair, who inspired the book
and made it her own.

Contents

Show Me The Place
(L.C.)

"You shall not make for yourself an image…"

All very well and good, and certainly true. But what if we aren't dealing with just a single image? What if we are dealing with the *many* images that accrue in the course of a person's lifetime and the images that others have made of that person? Taken in bright light or partial shade, alone or with friends, in an assumed pose, or as a chance snapshot that, in a fraction of a second, seeks to capture a moment that cannot be captured and only reaches us as a print in black & white or color: as just one of the perplexingly dissimilar pieces of the great life-puzzle that never quite fits together.

One flips through the pages of this photo book in a melancholy way, as if it were an old family album. Even if Leonard Cohen appears in every photograph, they are still picture puzzles and seek & find images. The search commences as soon as one opens the book: a young, good-looking man dressed in a suit and tie sitting upright in front of a typewriter – the mess on his desk gives the only indication that he is, in all probability, not an aspiring bank employee. But what the photo does not divulge, however, is an incident related by his biographer Anthony Reynolds: in the early sixties, when this picture was taken, Cohen once climbed into the bathtub with his green Olivetti in a bizarre attempt to write underwater. At the time, he was working on a volume of poems with the equally bizarre title *Flowers for Hitler*.

1968 in Nashville, Tennessee: an apparently stoned Cohen is lying in the grass. It is a skillfully skewed image that is both dizzying and disorienting; it seems as if

one is no longer standing on solid ground. It gives the impression that Cohen is hugging the earth in search of shelter. Twenty years later, in 1988 in the Netherlands, he pulls the collar of his coat tight and remains, for the moment at least, buttoned up.

Leonard Cohen was born on 21 September 1934 in the Royal Victoria Hospital in Montreal's Westmount district.

Westmount is an affluent quarter situated on a slope overlooking the city. Wealthy Anglophone Protestants live here, Anglican for the most part, as well as Canadian Jews. Living in a wooded enclave of villas above the Francophone metropolis, these two minorities in the east Canadian province of Quebec are bound together by their exclusive status as outsiders: neither of them have French roots nor are they Catholic.

My journey to Leonard Cohen has been ongoing for more than forty years now. It was the early summer of 2013 when I finally arrived at the foot of Mont Royal, intending to visit Cohen's childhood home at 599 Belmont Avenue the next day.

I have been traveling in search of him for decades; going in circles for the most part. At first, the record I had smuggled out of West Berlin spun endlessly in my attic room, while Cohen's sepia portrait on the album cover looked somberly upon the chaos that was my room. Later on, getting my acoustic drug was simpler – although much more impersonal: I simply pressed a button on the CD-player, and I could listen to my entire collection of Cohen CDs – from beginning to end – until I reached the beginning again and started over.

I still recall the magic moment when the needle fell into the groove of the shiny black vinyl and, after a short snap-crackle-pop, the first guitar chord rang out. Then, finally, his raspy voice. I was in the hopeless holding pattern of puberty, and Cohen told me poignant tales about beings I had never heard of before: the Sisters of Mercy, a Winter Lady, a Suzanne, a Marianne. *So long, Marianne*, I repeated his

words in a devout whisper. I didn't yet know that I would soon insert other names into this eternal formula of farewell.

Following an extended stay in the US, I decided to make a stop in Montreal. The perfect transit layover: I still had American prairie dust in my shoes, and I was already casting an eager eye in the direction of Europe.

The hotel was situated in the red light district. Despite this dubious location, it was really more of a spartan flophouse for mostly young backpackers from all over the world. One entered the room through a wardrobe/toilet/shower/dungeon. The room itself consisted of not much more than a corner fireplace and an iron bunk bed. The latter stood in front of the narrow window and confronted me with the choice of either sleeping on the top, directly under the ceiling, where I could spend a restful night if I didn't breathe too deeply, or on the bottom, where I could give my claustrophobic tendencies free rein. The a/c unit resembled a jet engine, both in size and noise level. It ran constantly. It had been unusually hot during the day, and a heavy thunderstorm had come crashing down over the city on the St. Lawrence River that evening.

So there I stood at one in the morning – smack dab in the middle of the red light district, in front of a one-star hotel. Terrific! My homeroom teacher, who always had a very high opinion of me, would probably not have even recognized me and probably taken me for a shocking specimen of late capitalism. I was the image of a shabby pilgrim: barefoot (my shoes were still soaked through from the rain; they were upstairs in the room), gray-haired, unkempt and unshaven, a bottle of water in my hand, a cigarette between my lips – and full of expectation.

I got an early start the next morning. In the underpass leading to the subway station, a street musician with curly, rust-red hair was pounding away at her guitar. Undauntedly she sang the verses of her famous fellow townsman to the unheeding passersby: "If it be your will / That I speak no more / And my voice be still / As it was before." She had a paper cup from Starbuck's in front of her. The small amount

of change it contained would hardly finance the guitar lessons she needed so badly. She played with such devotion – and so off-key – that it touched my heart and continued to echo in my ears for a long while down in the subterranean labyrinth.

I got off at Atwater Station. Not far from there, at Westmount High, Leonard had graduated in 1951. The sixteen-year-old's description of himself in the class yearbook reads like a prophecy: How would you describe yourself? – "The little man who is always there." (He remains so to this day.) Favorite pastimes? – "Leading sing-songs at intermissions." (When he was a small child, his mother Masha always sang Russian and Yiddish songs to him. Dislikes? – "The Coke machine." (The feeling was mutual. In contrast to Europe, his records never sold very well on the US market.) Ambition: "World Famous Orator."

As is so often the case in families, there seems to have been an occurrence of atavism here too. While Leonard has no overwhelming desire to enter into his deceased father's clothing business, the Freedman Company, he venerates his maternal grandfather, Rabbi Solomon Klonitsky-Kline. People had traveled hundreds of miles to hear him speak in the Lithuanian town of Kovno. All the same, he did inherit a lifelong penchant for elegant suits from his paternal line. In a remark that was both self-ironic and self-assured, he once told his interlocutress during an interview, "Darling, I was born in a suit." And in one of his later songs from 2012 he refers to himself in retrospect as a "lazy bastard living in a suit."

Wanting to become the type of speaker people make a pilgrimage to, and to whom they listen in rapture, nothing seemed more logical than acquiring a primer in hypnosis. His first attempt with the housemaid was promising. Cohen describes the experiment in his novel *The Favorite Game*. His mother has gone into town, and the eager young woman sits down on the Chesterfield sofa in the parlor as instructed. Very, very slowly swinging a pencil to and fro in front of her face, Leonard finally succeeds in putting her into a trance. At some point, with glazed eyes, she begins to take her clothes off.

A bit of advice in Chapter 2 of the little handbook had certainly been of valuable service to him: "Be quiet in all your actions. Let your voice grow lower, lower, till just above a whisper." It was a lesson he would often heed, especially later, on the somewhat larger stages of this world.

Although he now knows how to go about it, he still lacks a suitable instrument. As a small boy he had nearly driven his cohabitants crazy – and out of the house – trying for days on end to play "Old Black Joe" correctly on a cheap plastic flute. This experience gave him his first inkling of the power music can have; and like most adolescent boys, he plunked around aimlessly, but stubbornly, on a guitar.

He began writing poetry after discovering the poems of Federico Garcia Lorca in 1949 or 1950. Their intricate, oftentimes ballad-like simplicity, which is, at the same time, surreally enigmatic, would preoccupy him all his life. Then, in the early sixties, he had an encounter that can only be described as fateful.

One day on his way home, he saw a man playing flamenco guitar to a tiny group of listeners in Murray Hill Park (shown on current city maps as King Georg Park). Listening to this private performance, it seemed to Cohen as if he were hearing, for the first time, the strains that befit Lorca's texts.

"It was those six chords, it was that guitar pattern that has been the basis of all my songs and all my music," he would recall half a century later upon receiving the Prince of Asturias Award in 2011. It was an expression of thanks to his first and only guitar teacher. But he would only have three lessons. The fourth time he waited in vain. The young Spaniard had taken his own life.

For Cohen, the magic number three bestowed something fairytale-like and unreal upon this encounter: it seemed like providence.

Another episode from his early childhood is similarly auspicious. In the winter of 1944, right after his father's funeral, nine-year-old Leonard took a silk bowtie from his father's wardrobe, cut it open, put a piece of paper in it on which he had written a few lines, sewed it back up, and buried it outside in the wintry yard. To

this day, it seems, Cohen is still searching for the strains of that flamenco guitar that have faded away forever; he is still searching for the words on that buried piece of paper.

The further up one goes from the direction of Rue Sherbrooke, the more British the Westmount district becomes: old Victorian houses and villas; well-kept English lawns; yards that seem like overgrown miniature parks. The concentration of BMWs and Volvos is visibly higher than down below in town. I passed by a synagogue and, a little later, an Anglican church on Rue Sherbrooke.

Leonard Cohen also possesses this immediate proximity of dry British humor and Jewish tradition. Understatement in its purest form. It is, in any case, half joke and all truth when he remarks during an interview on Canadian television, "… the fact that the lines I write don't come to the end of the page doesn't qualify me as a poet." And aren't his artful reductionism and minimalism, which he has cultivated all his life, also attributable to an age-old tradition that has been handed down over a multitude of generations?

In a Hasidic tale, a father invites the town's most eminent men to his daughter's wedding. They sit waiting for the feast to begin. And what is placed before them? Nothing but clear water from the well. "What is the meaning of this, Reb Jankel?" the astonished guests ask. He explains. Because he wanted only the best of the best, he went to the market himself to buy fish. The fishmonger said, "My fish are the best in the world. They are as sweet as sugar." So he decided to buy sugar. The greengrocer said "My sugar is as sweet as honey." Jankel asked himself, "Why don't I just buy honey?" and went on his way. The beekeeper said that his honey was as clear as olive oil. Jankel went off in search of olive oil. The merchant said to him: "I will give you the finest olive oil – as clear as water." Then he knew what had to be done. "And that is why I have served you water, because for my guests, only the very best will do."

Cohen astutely absorbed this talent for transforming the over-refined into the

simple. From the outset, he opted for the simple – burnishing it until it was perfect: as perfect as the sacred, sober water in the tale. One of his producers, Lissauer by name, described Cohen's special style thus: "Leonard would only sing safe intervals. He wouldn't sing like a singer, he'd sing like a tough poet." Because his lyrics are actually poems, his CDs always include a booklet of printed lyrics. "He sang," says Lissauer, "in the same range in which he talked." The result is the recitative style found on his latest CD that is so characteristic of Cohen's mature works.

He also displays a headstrong minimalism in his choice of musical instruments. Whereas his fellow musicians buy instruments for tens of thousands of dollars, he bought himself a Casio keyboard with 49 keys – the kind you get in toy stores – for 99 dollars. Thenceforth it is his constant companion, and it can be set up in the tiny hotel rooms he later prefers on his world tours: in contrast to spacious multi-room suites, he doesn't have to spend half the morning gathering up his things from the far-flung corners of a penthouse.

Not far from his parental home: a tennis court. It's a busy place this morning. Under the maple trees (Canada!), seniors are playing pétanque. And so, as I approach Belmont Avenue on this Saturday in June with the sun almost at its zenith, a sort of holiday atmosphere arises.

And no photo album should be without vacation photographs. Following a rainy stay in London spent studying and writing, Cohen fled to the Greek island of Hydra. Thanks to an inheritance of $1,500 he was able to buy one of the old white island houses there. An international artists' colony arose on Hydra during the sixties. At first glance, the photographs taken during this period do indeed give the impression of a vacation, of dropping out of society, and of a fresh breath of Aegean summer air. But Cohen will spend the next years there doing one thing: working hard.

On the photograph of him in the mountains sitting on a donkey, at least, he doesn't appear very relaxed or touristy. He prefers to ride side-saddle and looks a bit like an English Lady who is not very amused.

Two novels and a volume of poems are the upshot. The latter sells a few hundred copies. Despite positive reviews: a career as a disregarded poet was not exactly what he had had in mind when he started out. During one of the many award ceremonies he would later attend (Cohen: "We shuffle behind our songs into the Hall of Fame."), the speaker specifically thanked those of her compatriots who had *not* bought Cohen's early poems and novels: without them, the songwriter would never have emerged.

If one stands in the harbor on the bay, the buildings of the small city seem like the large semi-circle of an ancient amphitheater. And the spot in the harbor is transformed into a stage below the endless blue backdrop of the shimmering Mediterranean sky: a virtual prelude to the concerts he will give in the years ahead on the stages of nearly all the great halls and arenas of the world.

My one and only Cohen record cracked after years of intense non-stop play; and at some point, my record player gave up the ghost. As odd as it may seem, Cohen didn't (and still doesn't) get much radio play, meaning that I couldn't access him via the airwaves. So it came to pass that I heard nothing of his for quite a long while. 1989 brought the freedom to travel, and I was able to continue my journey to him.

One day in a shop on Kurfürstendamm – I was looking for an Eric Clapton CD I needed for a radio production – I found an entire Cohen collection right beside it in the box marked "C." This put me in a nostalgic mood. My initial intention was to get his old songs on CD for the sake of completeness, but I was shocked and amazed to see all that had come out in the meantime and what I had missed: from *New Skin For The Old Ceremony,* to *Various Positions,* and the CD *I'm Your Man,* which was released in 1988 and featured the song "First We Take Manhattan."

It's a pity we didn't know that song back then. When Cohen later performed it in Berlin, the audience jumped out of their seats at the refrain "Then We Take Berlin" and was spontaneously transformed into a choir of thousands.

During the eighties a Polish version of "The Partisan" became the unofficial hymn of the Solidarity movement; Cohen learned of this while on a four-concert tour of Poland in 1985. This visit was also very moving for him because it was the first time he had ever been near Lithuania, where part of his family came from.

"The Future World Tour" kicked off on 25 April 1993. It ran until 30 July, with 63 concerts in Europe, the US, and Canada. An unbelievable workload. During this time, a 1982 Château Latour is his medium of choice for attaining the right operating temperature for the concerts.

In his novel *Beautiful Losers* he writes: "If I'm empty then I can receive, if I can receive it means it comes from somewhere outside of me, and if it comes from outside of me I'm not alone." After the overabundance of fleeting, changing impressions on this tour, it is possible that he couldn't absorb any more; that it was exactly this spiritual center and emptiness that was increasingly lacking when he stood all alone at the edge of the stage, night after night.

The Mount Baldy Zen Center is a monastery located in the mountains 80 kilometers east of Los Angeles. At 2000 meters in elevation, the air is thin in this rugged, stony landscape. In August of 1993, after completion of "The Future World Tour," Cohen goes into seclusion there. He will live there for the next few years.

Days that begin early at 5 a.m., during some periods as early as 3; days that are full of meditation, singing, silence, and simple work tasks.

The black dog that strayed into the photograph from 1995 and is being fed by gray-haired novice Leonard seems like a four-legged envoy from another world. Perhaps he reminded Cohen for a brief moment of the little dog he had while still a schoolboy in Montreal.

His teacher Roshi is editor of a Buddhist magazine and Cohen contributes to it as an author: *Zero*. This zero stands for the assumption that all things – the positive and the negative, light and darkness, good and evil – at some point synthesize and are reconciled in God. There is a photograph from 1978 that anticipates just this

thought: Cohen is leaning on a tree, or the tree is leaning on him. The two are in harmony; each seems to support the other. For a moment, so it appears, everything is in balance.

Although he is ordained a Buddhist monk in 1996 – he is given the name Jikan, "the Quiet One" – Cohen nevertheless ultimately returns to worldly life, having realized that he is not cut out for religion.

Following the superb *Ten New Songs* from 2001, which can be regarded as the summary of his years in the monastery (in the front of the booklet: a picture of his teacher Roshi), the album *Dear Heather* was released in 2004. With its tranquility and serenity, it almost sounds like a late work. As his biographer Sylvie Simmons writes, he flew to Montreal as soon as the mixing was completed in the studio and spent the summer sitting in the Parc du Portugal with the other old men. The album sold well, made the international charts, and Cohen could dispense with going on tour again. At least that's what he thought.

A wise Zen Buddhist answer to the question "What is the essence of mind?" is "Reality."

In the fall of 2004, reality did, in fact, have a brusque test in store for Cohen, one he never would have thought possible while he was up in the mountains or sitting on the park bench in Montreal. In October of 2004, shortly after his seventieth birthday, he was informed that his longtime confidante and manager Kelley Lynch had used his time-out in the monastery to pilfer all the money that was supposed to finance his retirement. The police searched her house in vain while Lynch's gray parrot looked on from its perch, repeating gloomily over and over, "I see dead people! I see dead people!" Luckily, this comic bird would prove wrong. Indeed, someone other than Cohen would probably have been shattered by such a total financial loss. But after his years in the monastery, Cohen's comment on the disaster was cool and laconic: "It's enough to put a dent in your mood."

And it gives him occasion to reconsider touring again in order to recoup the lost

money. On 11 May 2008, the seventy-three-year-old sets out on his first tour in fifteen years. This resurrection tour will take him all around the world and last until 11 December 2010 – a staggering two and a half years.

From the outset, as Anthony Reynolds notes, Cohen seemed much older than his contemporaries. As early as 1985 he had been introduced as a "living legend" in Australia. A quarter century later, he still is – or: more so than ever. Sylvie Simmons compares him to an aged French chansonnier who accidently ends up in a disco. Even the smoke signals of his cigarette seem to send the same message. Pursuing this path, he grew increasingly quiet and increasingly elegant with the years. Not forever young, but instead: almost young.

His voice has grown so quiet that everyone in the audience feels he is speaking directly to him or her (!). It is especially palpable in his older songs: rooted in the vicissitudes of experience, they give the impression that he required a lifetime to finally find the right intonation for them. Sung by an old man, they suddenly sound entirely new.

If there really is such a thing as dignity in old age, it is plainly visible in his concerts: in the way Cohen passes his legacy on to his younger colleagues on the stage. Nearly disengaged from the concert, they celebrate his songs. His band members perform breathtaking instrumental and vocal solos, and Cohen – quite literally – doffs his hat to them, presses it to his breast, and reverently kneels down before them. He then rises again in order to pay reverence to the next soloist and again doff his gangster hat, which has meanwhile become standard headgear for the entire band.

During the Berlin concert at O_2-World, Cohen breezed over the stage with near-youthful élan; but at the break, when he reached the small stairs leading from the stage and the spotlight had just gone out, one could see the sudden transformation: it was an old man who cautiously descended the iron stairs, step by step, firmly gripping the banister. The carpet placed on the stage imparted something of a living

room atmosphere during the concert – even in front of the thousands of viewers and listeners in the huge, impersonal arena.

His latest album at this writing is titled *Old Ideas*. The first track is "Going Home," and the third is a masterpiece of melancholy, "Show Me The Place." And there I now stand, at twelve noon, at The Place: 599 Belmont Avenue. Who would have thought, old boy? Under a spreading maple tree, it is the corner house in a row of houses, brick and white wood. For a rich neighborhood, it seems a bit modest. Six steps lead up to the front porch.

I am being watched from the other side of the street. In one of the front yards, a small white dog of the Heinz 57 variety is attentively watching my every step. For that reason – and because I'm no longer a teenager – I do not proudly raise my index and middle fingers in a victory sign or take an embarrassing photo at the finish line.

Critics have faulted *Old Ideas*, claiming that, compared to the absolutely perfect performances of the world tour, it sounds like a demo recording; and they ask themselves why he didn't take his entire tour band into the recording studio. But the band members are strewn about the globe. And perhaps he wanted it just the way it is and not in any other way – totally personal: "Going home / Without my sorrow / Going home / Sometime tomorrow / Going home / To where it's better / Than before / Going home / Without my burden / Going home / Behind the curtain / Going home / Without the costume / That I wore."

Asked about death during a press conference in Paris in 2012, he answered with his usual nonchalance: "I have come to the conclusion, reluctantly, that I'm going to die." But when asked what he would like to be reincarnated as in his next life, he had a ready answer that is unquestionably true: "I would like to come back as my daughter's dog."

Tinky, a small Scottish terrier, whom Cohen's mother wanted to name Tovarich

(comrade), was the creature he was closest to in his childhood. He slept under Leonard's bed, followed him to school, and waited there for him. Tinky died at the age of 13. It was a winter night, and he didn't come home. Not until spring, when the snow melted, did they find his remains under the neighbor's porch.

Cohen interprets this discrete retreat from the world thus: "It was some kind of charity to his owners." To this day, a framed photograph of him stands on a dresser in Cohen's Los Angeles home.

Turning to leave, I stop and glance back one more time: the little white dog lying in front of the porch across the street has stretched out on the lawn. With eyes shut, he lies in the sun. One cannot fail to notice how deeply he is now lost in meditation.

Jens Sparschuh, March 2014

The Young Poet

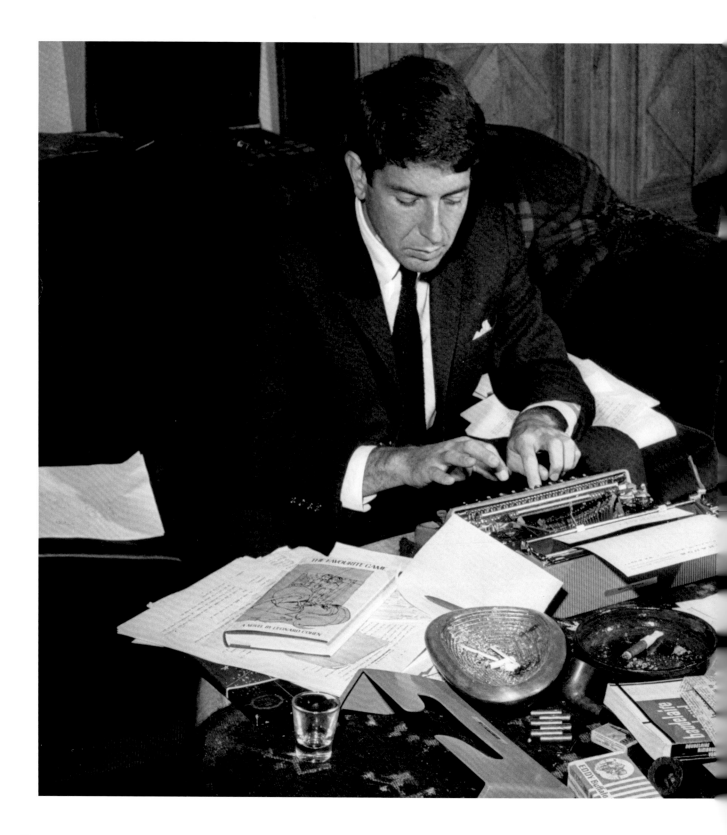

Leonard Cohen with what remains his most important tool: his green Olivetti typewriter. He purchased it in 1959 in London to write his first novel, *The Favourite Game*. Prior to this, he had already made a name for himself as a lyric poet among Canada's literary cognoscenti while still in college. This photograph taken in 1963 shows the ambitious young poet dressed in what was then the style of his conservative background: in a suit and tie.
Photo: Allan R. Leishman

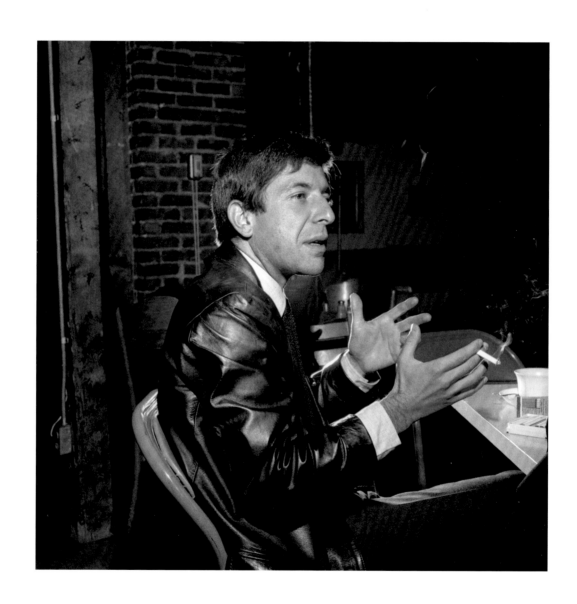

The aspiring poet in conversation in his native city, Montreal, in 1964.
That same year, he won the Quebec Literary Competition Prize
for his first novel, *The Favourite Game.* Photo: Allan Blackham

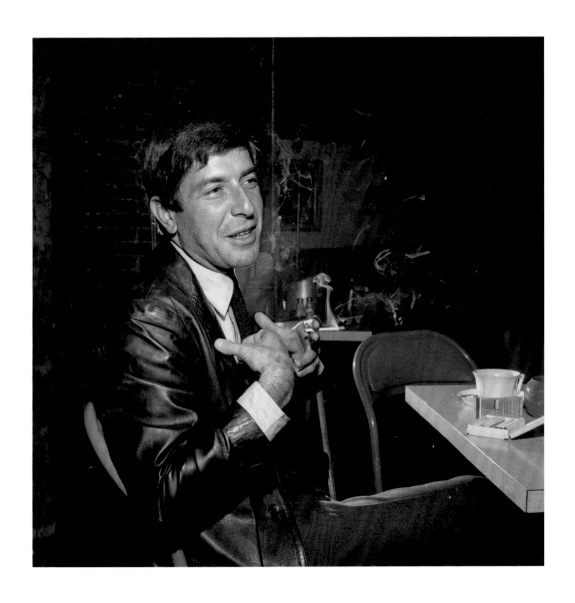

An interesting fact: at the time, the book had only been published in the US
and Great Britain, but not in Canada – because Leonard's publisher,
McClelland, had rejected the novel. Photo: Allan Blackham

Hydra

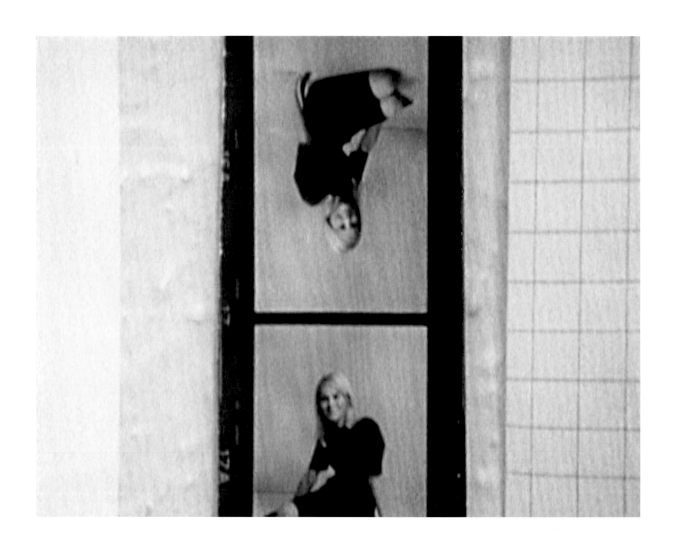

Marianne Jensen, née Ihlen, met Leonard Cohen on the Greek island of Hydra.
The young Norwegian had already been living in the artists' colony there for several years
when Leonard chose her as his muse and moved in with her and her small son Axel.
Top photo: still from the movie *Ladies and Gentlemen, Mister Leonard Cohen*.
Right photo: James Burke

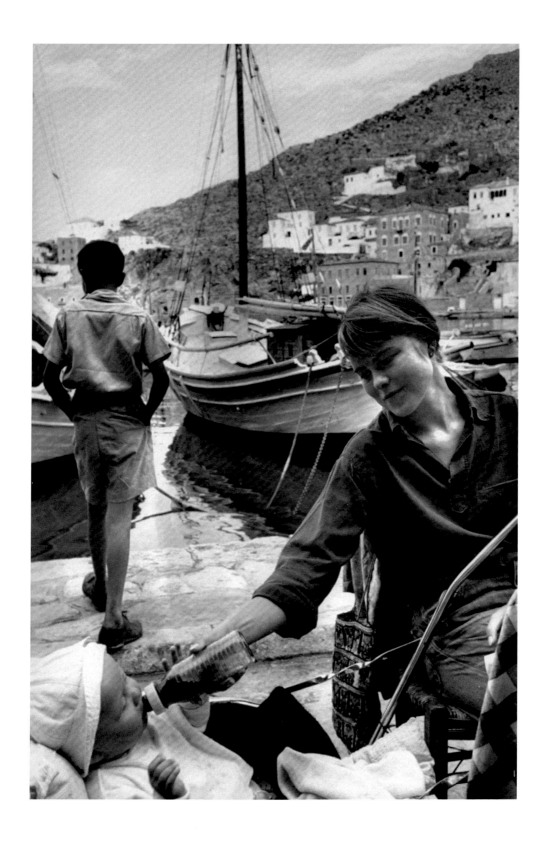

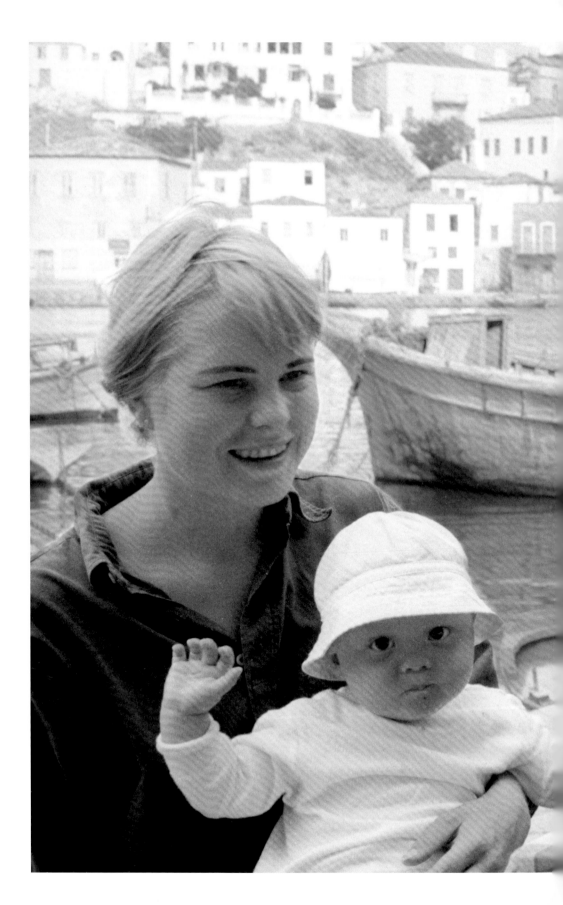

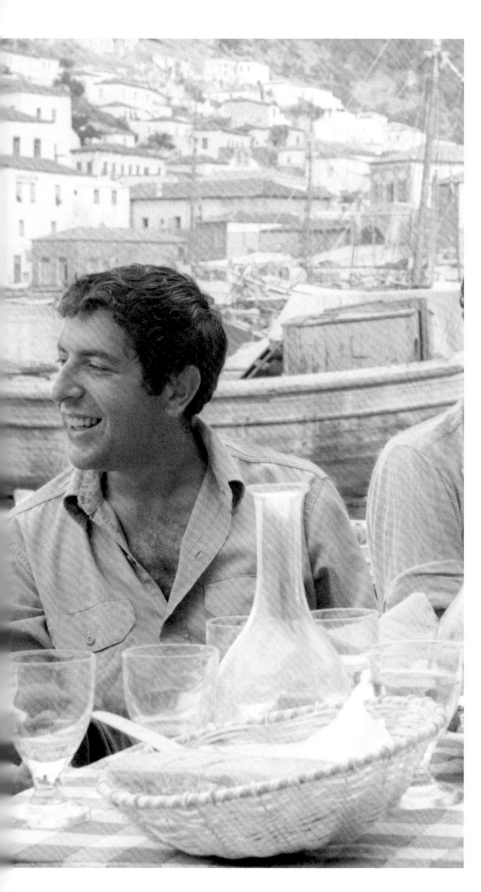

The man who speaks with a golden tongue: Marianne Jensen later relates how her grandmother foretold her meeting Leonard with these words while she was still a child. Photo: James Burke

31

The harbor café was the meeting point for everyone who was trying
to make a living from their art on Hydra. This was because the mail arrived
once a week by ship, bringing eagerly awaited checks. Writer Axel Jensen (center),
who was still married to Marianne at the time. Photo: James Burke

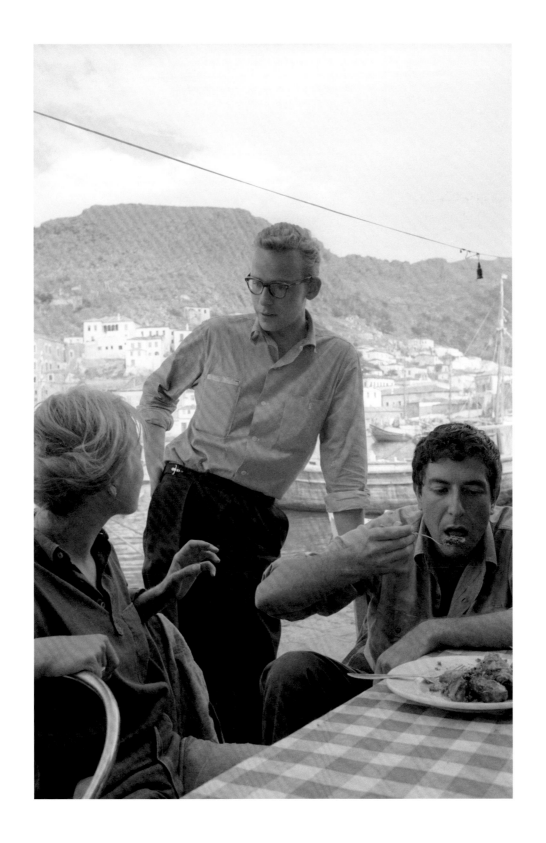

Working, swimming, getting together with friends at the café:
these activities set the rhythm for Leonard Cohen's, intermittently,
very productive literary life on the island. Photo: James Burke

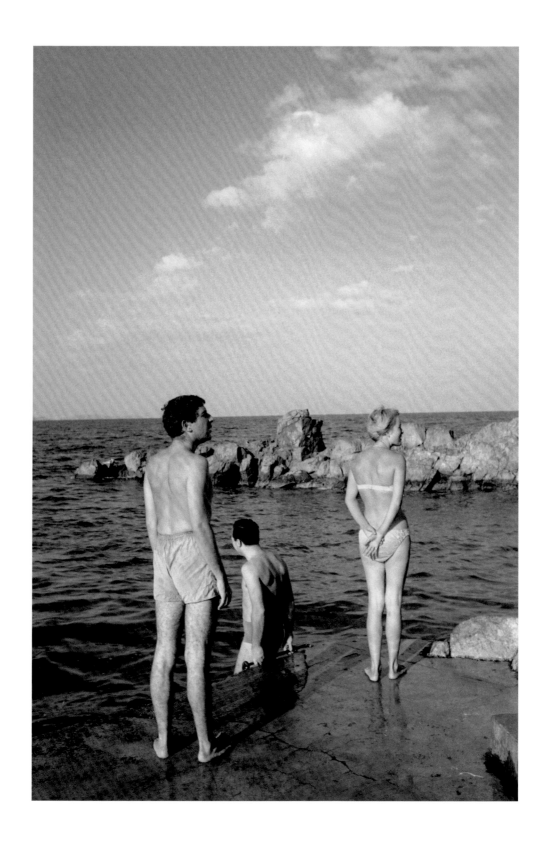

Just like in Biblical times: Since there were (and are) no automobiles on Hydra,
donkeys were the preferred means of conveyance. The barrenness and simplicity fascinated
Cohen so much that he immediately fell in love with the island. Photos: James Burke

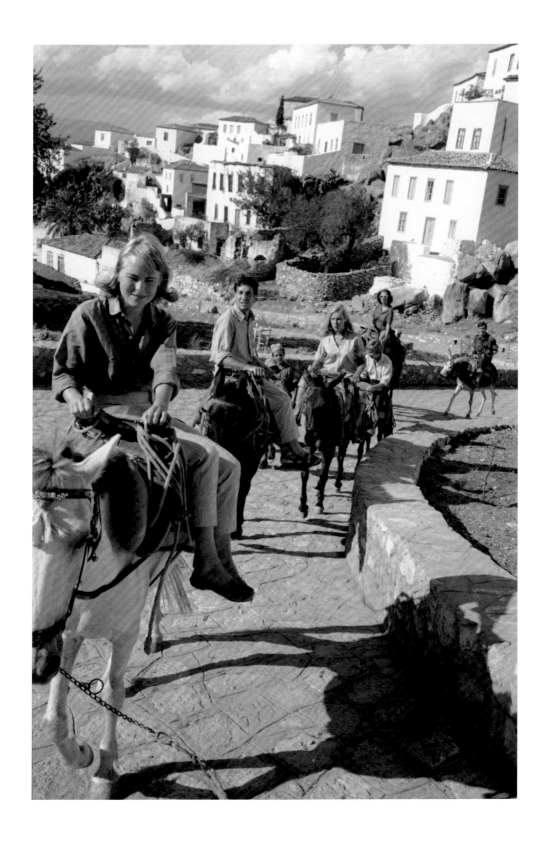

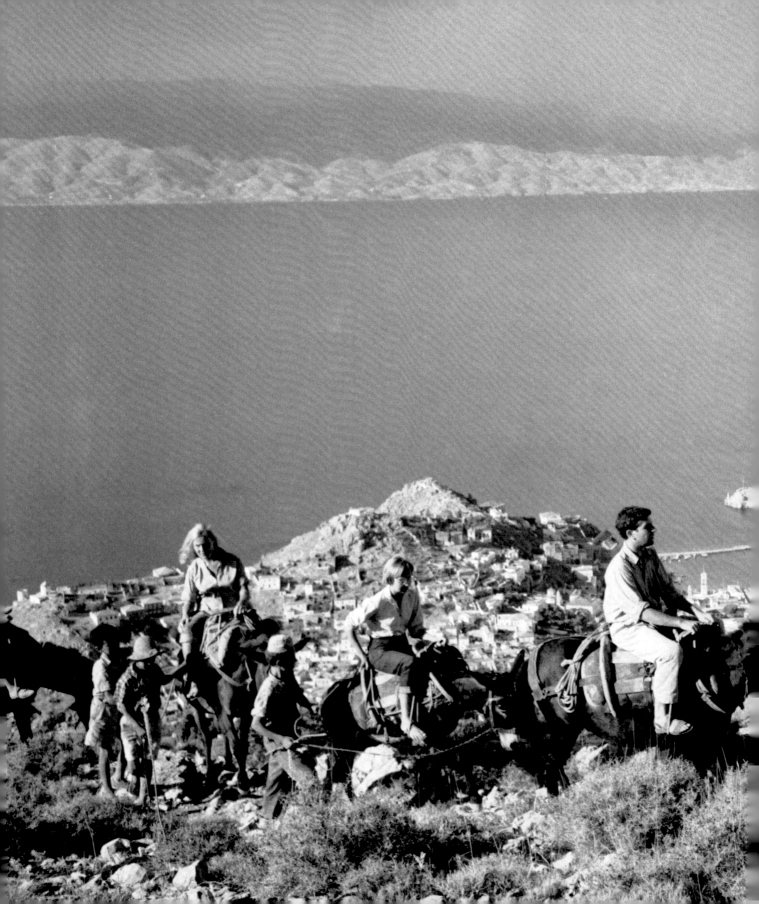

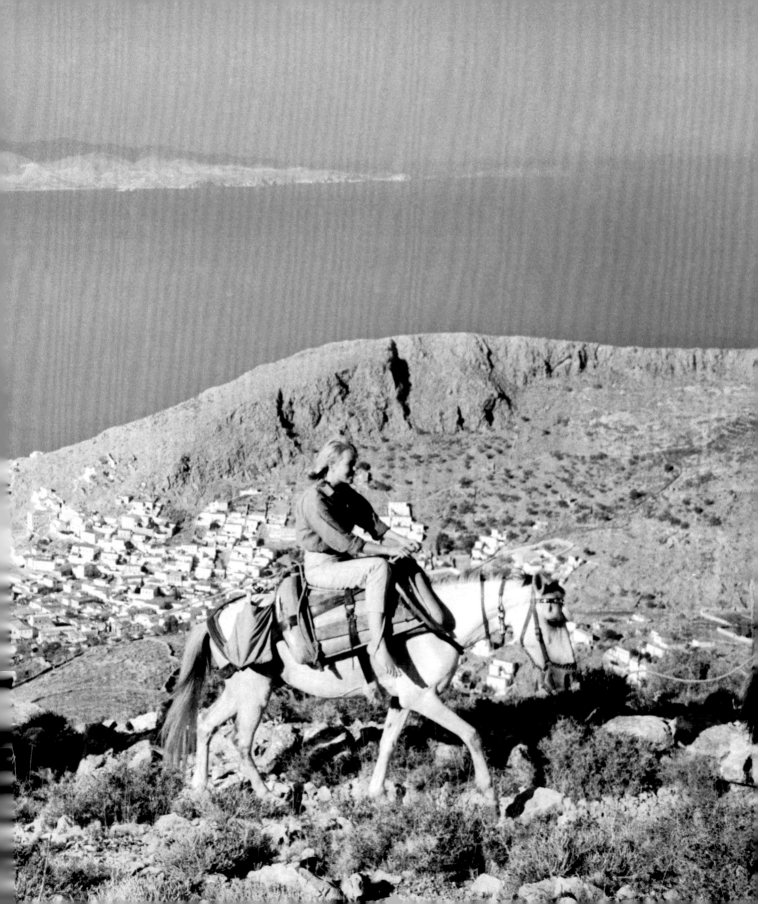

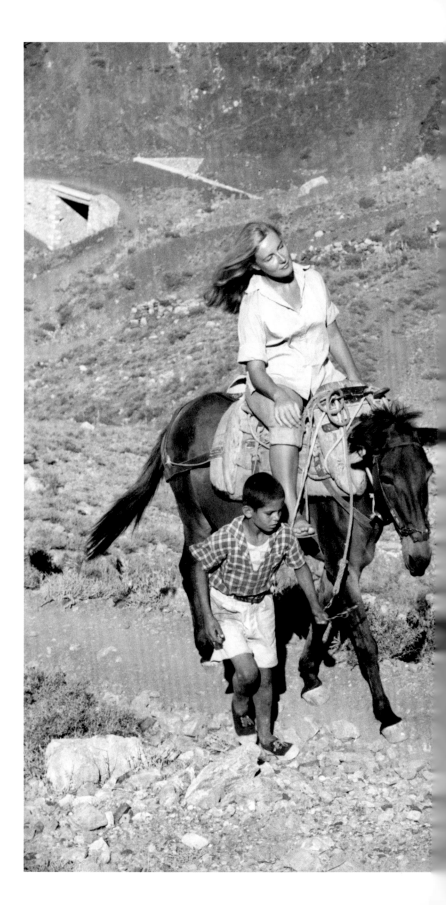

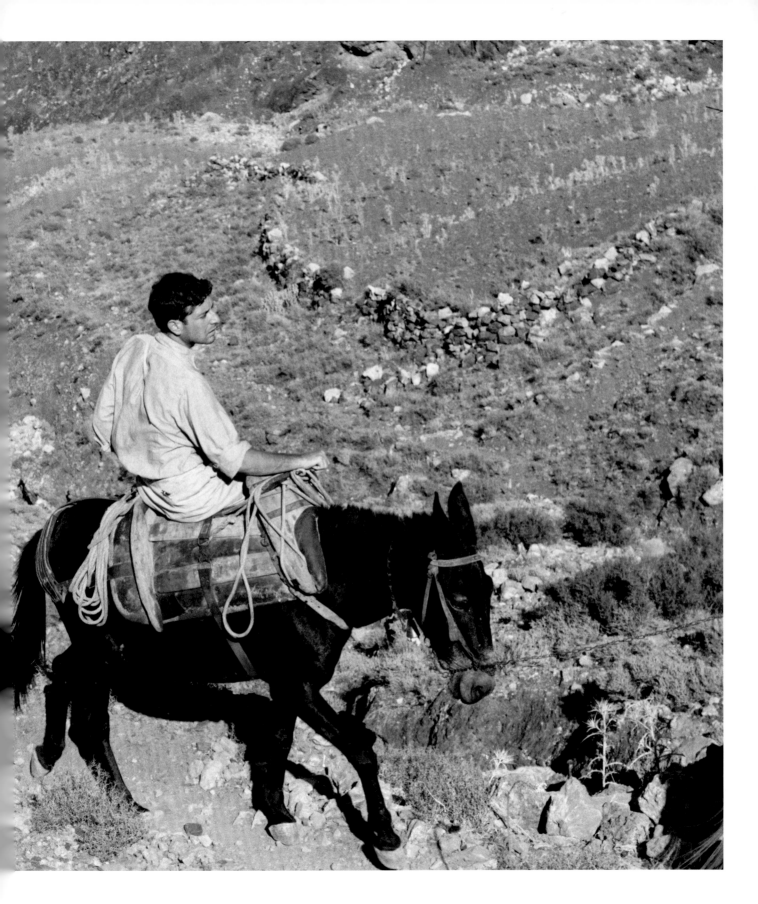

Bohemian life – in anticipation of the yet-to-come Hippie movement –
included singing together to guitar music: here with Australian author Charmian Clift,
who had founded the artists' colony several years earlier with
her husband George Johnston. Photo: James Burke

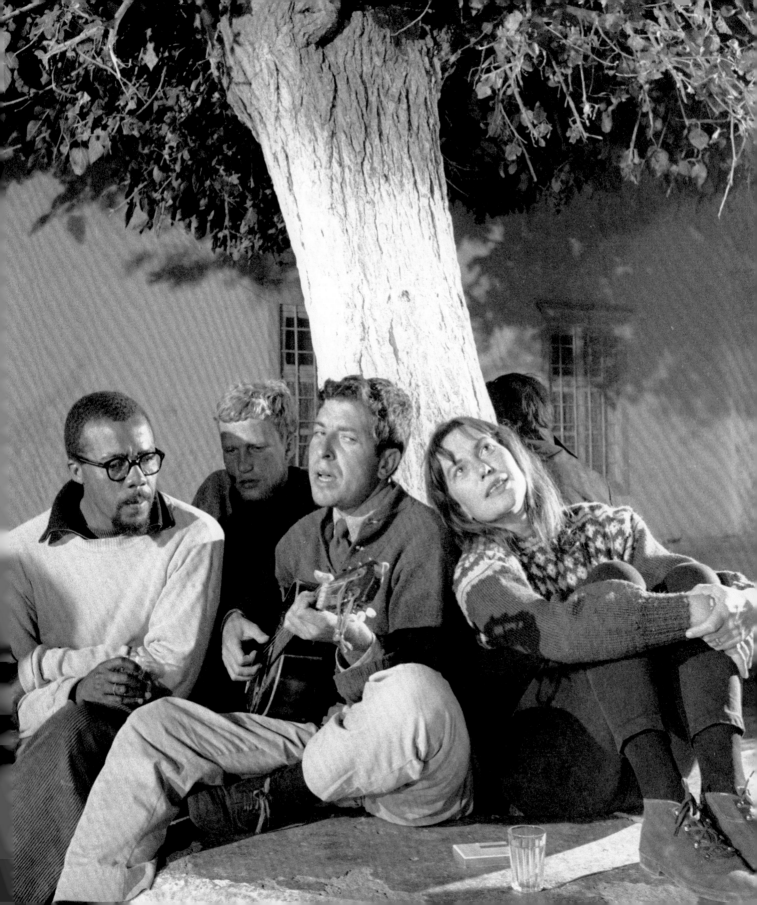

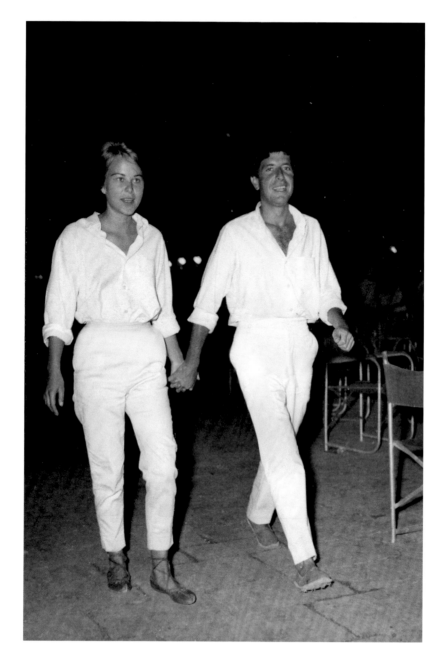

Leonard with Marianne, for whom he wrote the immortal song of farewell "So long, Marianne,"
taking a walk along the harbor on a summer night in Hydra, 1963.

"She brought a tremendous sense of order into my life … Just the way she laid a table or lit candles …
and she wasn't by any means confined to these activities that have come under the suspicion of feminists.
It wasn't just that she was the Muse, shining in front of the poet. She understood that
it was a good idea to get me to my desk." Leonard on Marianne, 1994

Newport, 1962

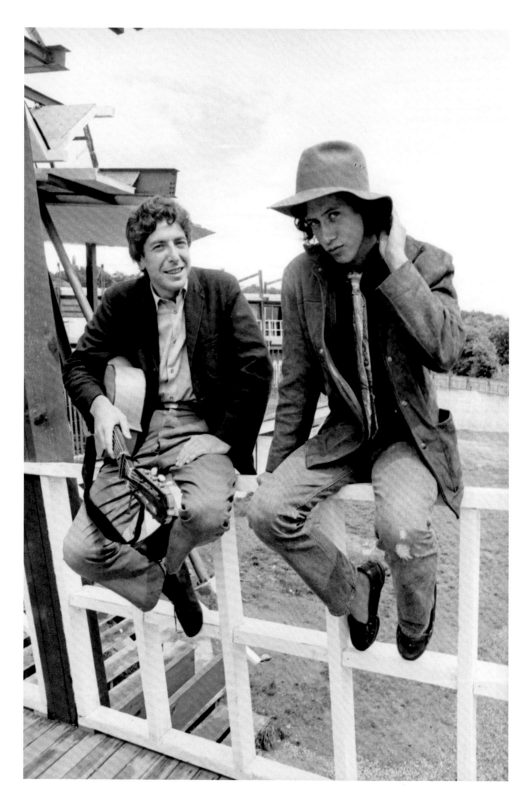

New colleagues: with Arlo Guthrie …

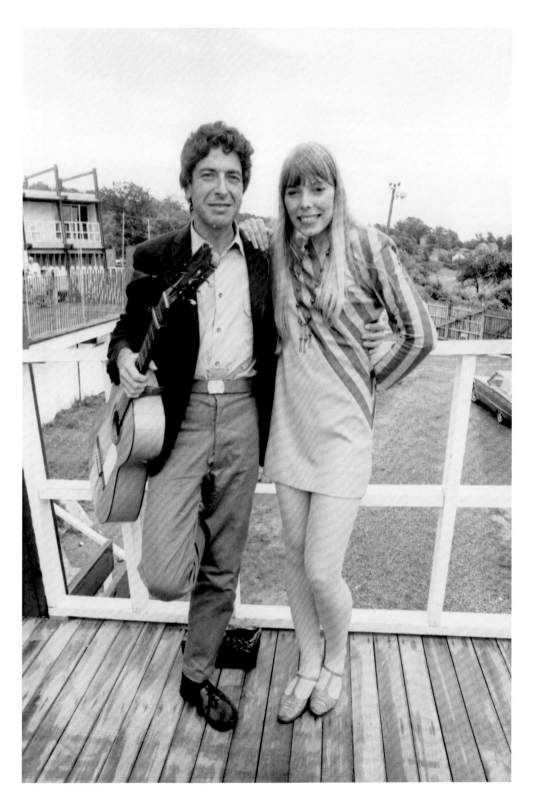

… and Joni Mitchell, 1967 in Newport. Photos: David Gahr

Backstage at the festival in Newport: when he performed
there in July 1967, Cohen had no records on the market.
He had discontinued recording his first album,
Songs Of Leonard Cohen, in favor of numerous
live appearances. Photo: David Gahr

48

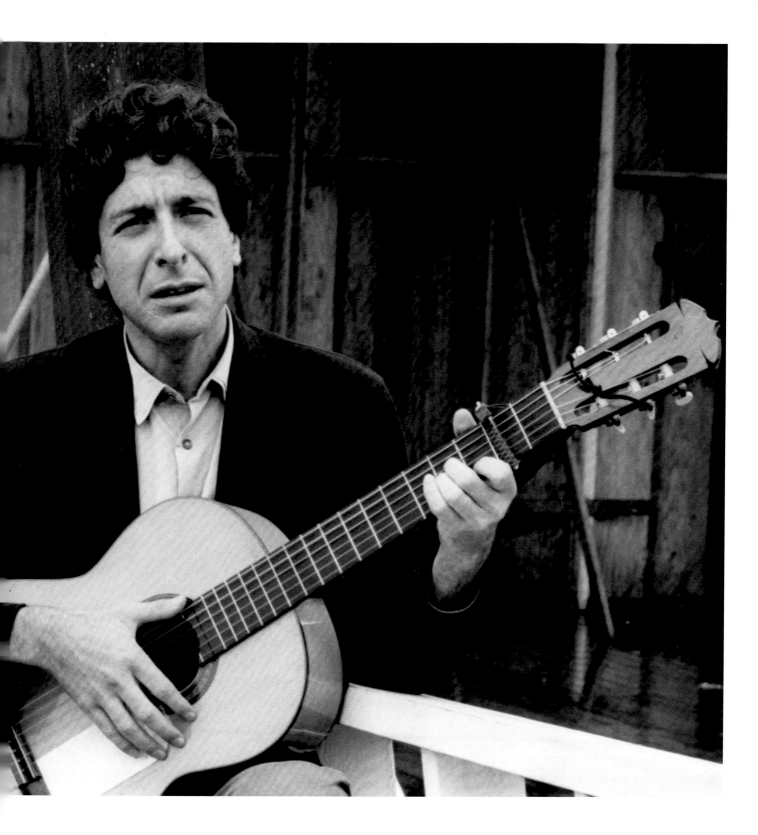

A new business: the Newport Folk Festival in Rhode Island was Leonard's first large-scale music festival. He had witnessed folk's – electrically amplified – renaissance the year before in the New York music scene centered around Bob Dylan, Joan Baez, and Judy Collins. That was when he decided he would earn his living with music. Photo: David Gahr

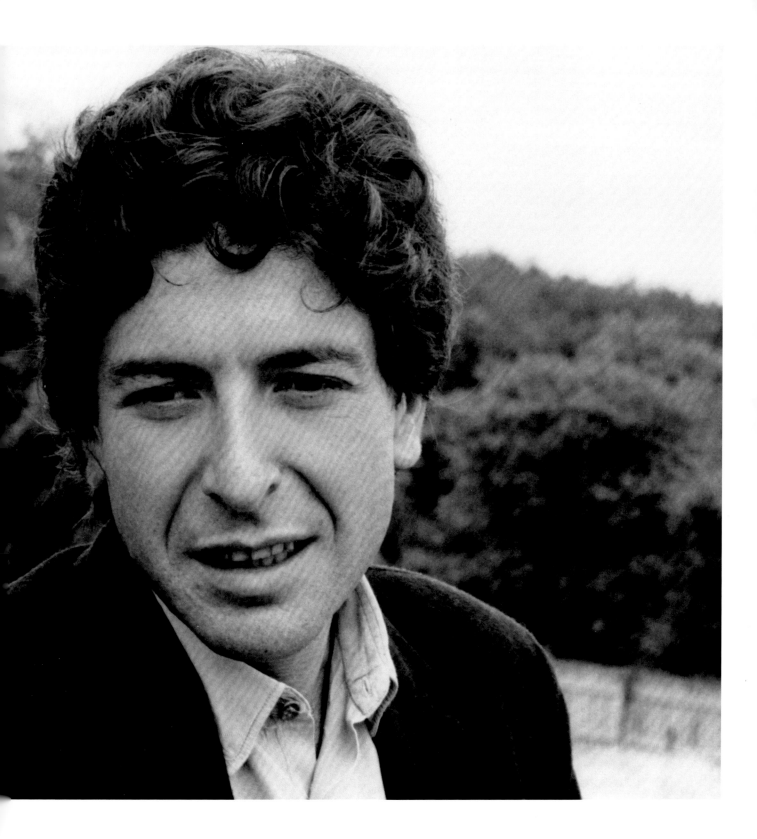

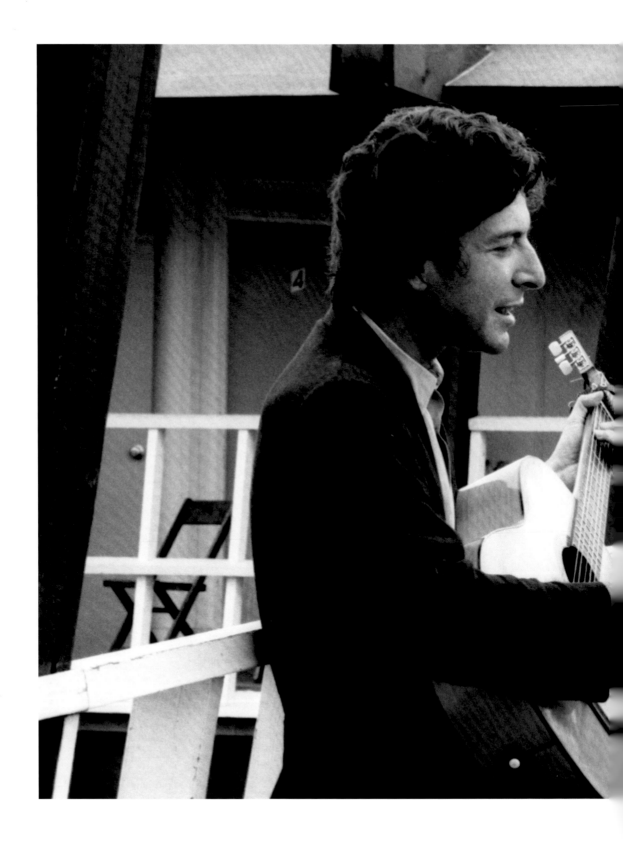

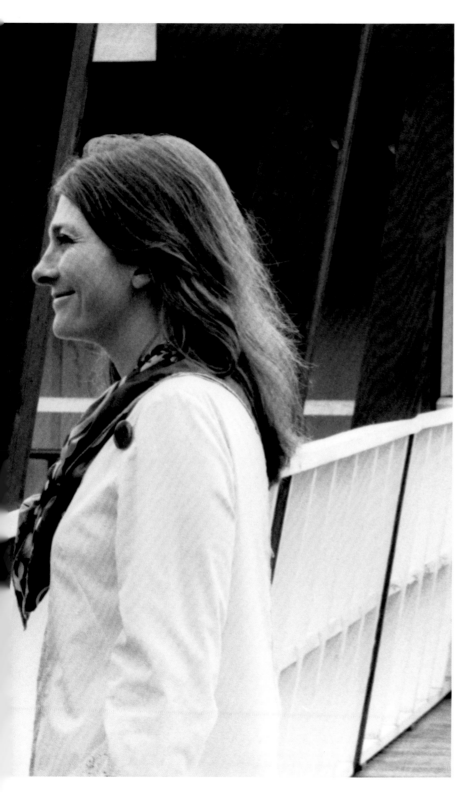

With festival organizer Judy Collins: she
was the first singer to cover Leonard Cohen's
songs before he performed them in public.
In 1966 she recorded two Cohen songs for
her album *In My Life*: "Dress Rehearsal Rag"
and "Suzanne"! It was also she who encouraged
him to make his first live appearances in
front of a large audience. Photo: David Gahr

Songs of Leonard Cohen

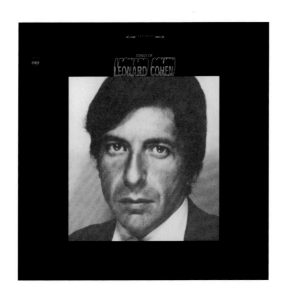

The singer-songwriter is born: his first album, *Songs Of Leonard Cohen,* is released in December 1967.
It includes the classics "Suzanne,'"'So long, Marianne," and "Sisters of Mercy." The response of critics and
listeners is mixed. It is much more reserved in the US than in Britain, where the album makes the Top 20.
At 33, Cohen was "almost an old man" in the music scene. With the cover photo (previous page) taken
in a photo booth in a New York subway, he made no attempt to hide his age.
Right photo: Jack Robinson

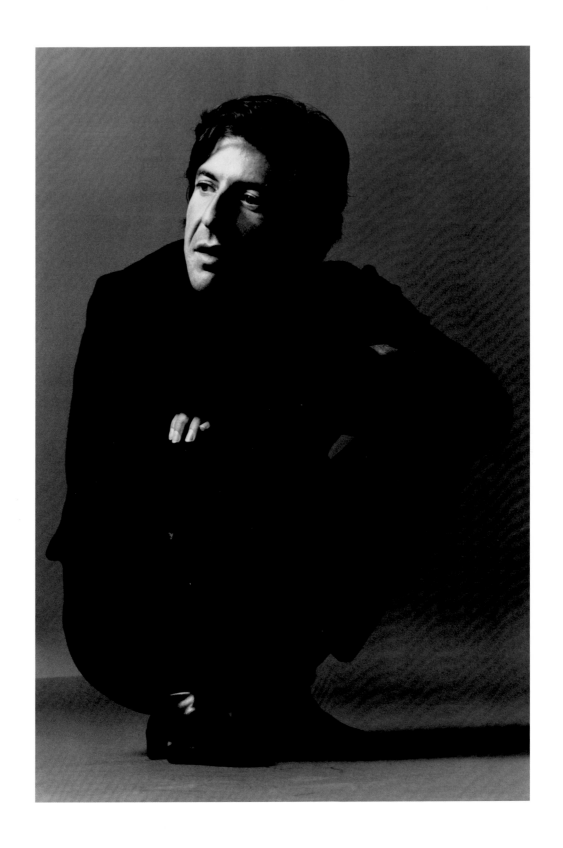

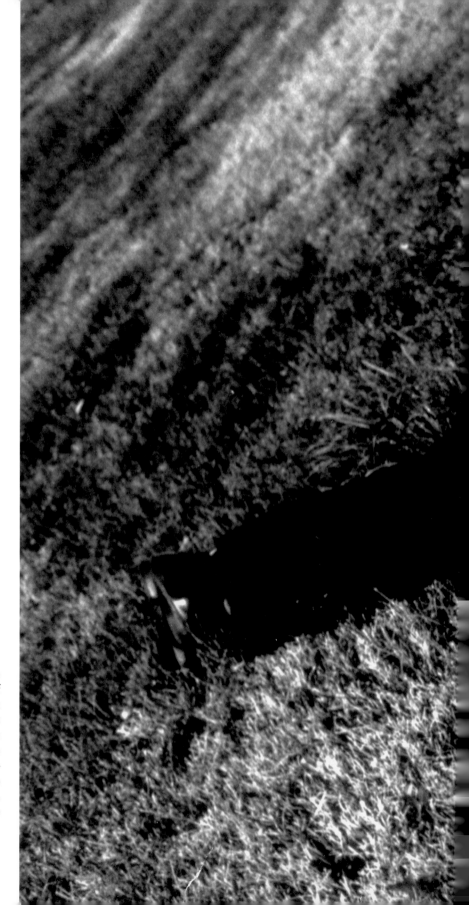

Looking stoned in the grass, cigarette in hand: one of the many facets of Leonard Cohen. In late 1968 he leased a farm in Tennessee for two years in order to live out his notion of frontier life. In the interim, he recorded two albums – *Songs From A Room* and *Songs Of Love And Hate* – in Nashville, the city he had intended to make music in when he initially left Hydra. Photo: Tony Vaccaro

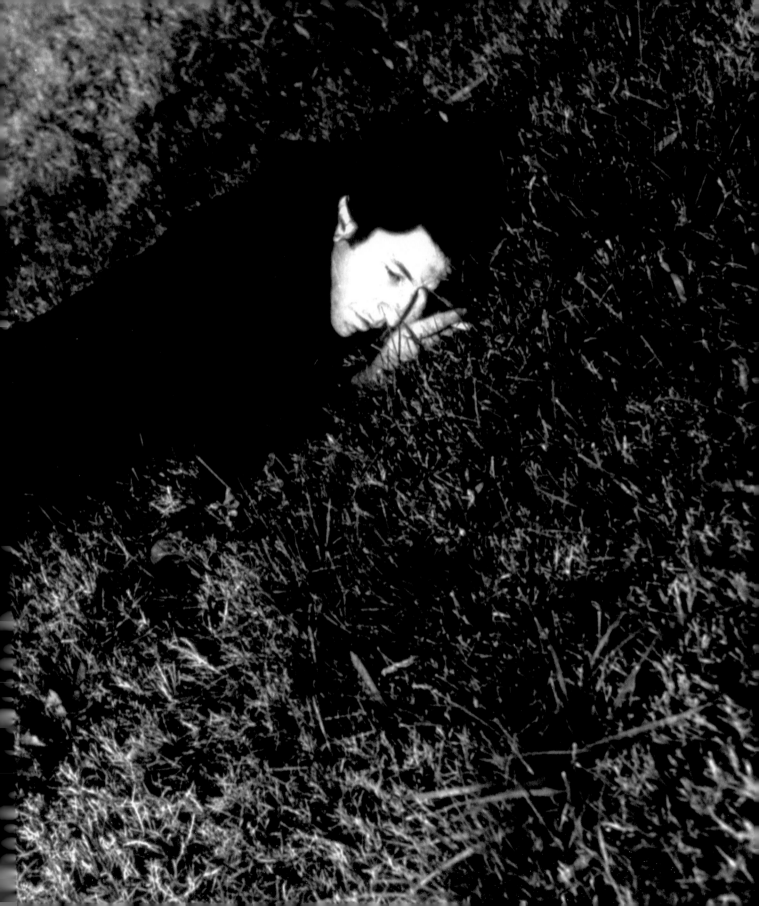

In a self-assured pose, 1968 in a New York diner: the sales of Leonard's latest volume of poetry, *Selected Poems*, were magnificent, probably due to his increased renown in the wake of his music albums. He is nominated for the Governor General's Award, but declines. Photo: Roz Kelly

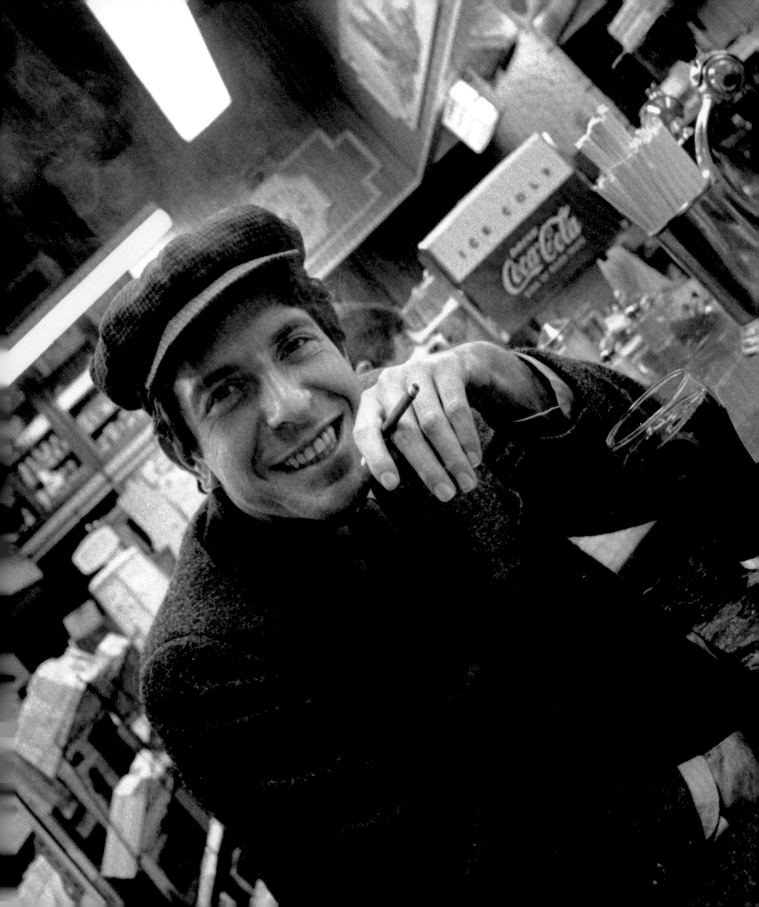

1970 – a contemplative Leonard Cohen looks towards a new decade.
It had unfamiliar tasks in store: his record company, Columbia, pressured him to go
on tour, to Europe. He dreaded performing in front of large audiences so much that he asked
his friend, sculptor Mort Rosengarten, to make a mask for him, which he intended to wear on stage.
Instead of the mask, he finally resorted to large quantities of assorted drugs.
The European tour was a success.

The 70s

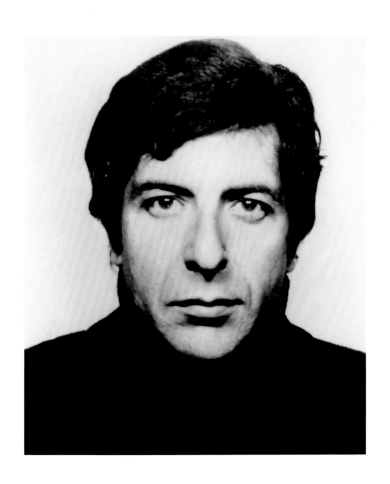

The crowd charmer in a tropical suit: during the Isle of Wight Festival in August 1970, an audience of over 650,000 – instead of the expected 150,000 – descended on the Channel island. Enraged by ticket prices they felt were too high, a few malcontents set the stage on fire during Jimi Hendrix's performance. At two in the morning, "Captain Mandrax," as Leonard Cohen was known to his band in allusion to his drug of choice, succeeded in calming down the rain-soaked and angry audience. Photo: Michael Putland

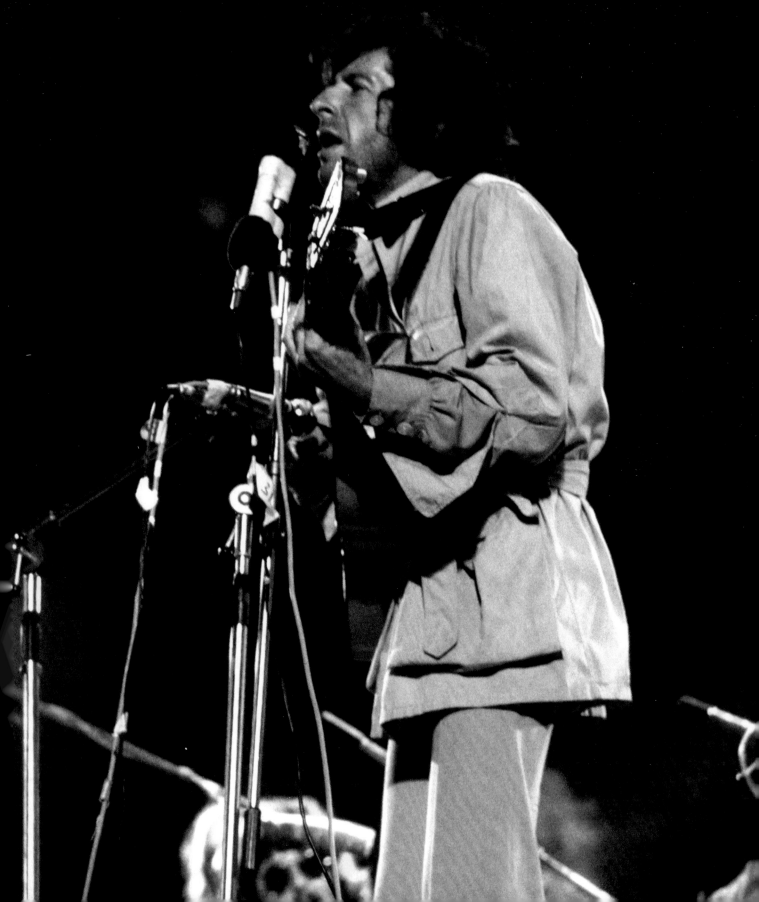

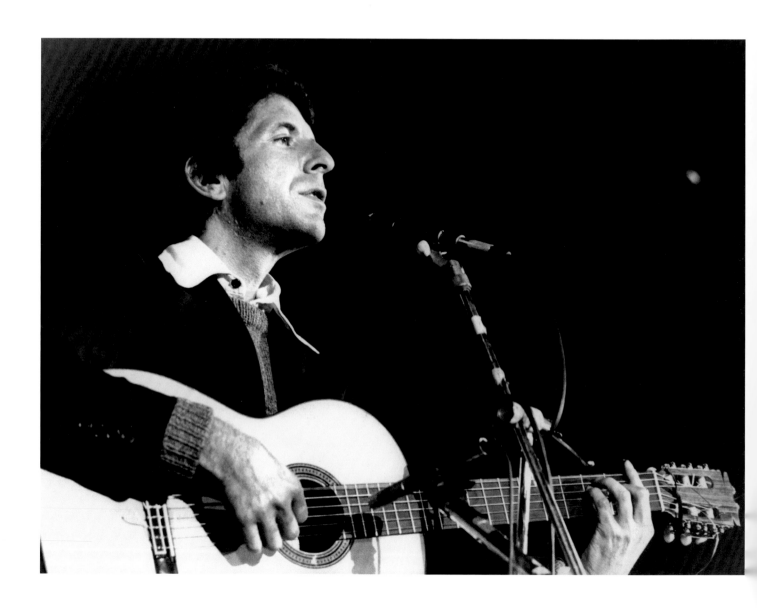

March 1972 found Cohen once again on European tour. Within a month
he played in 19 cities to sold-out venues in Berlin, Hamburg, Manchester, London –
here in the Royal Albert Hall (right) –, Paris, and, finally, in Tel Aviv and Jerusalem.
Right photo: Gus Stewart

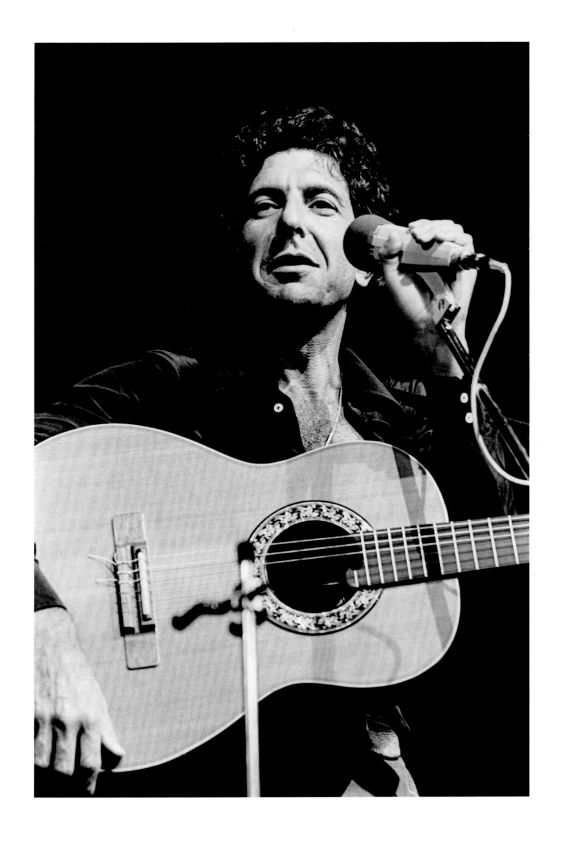

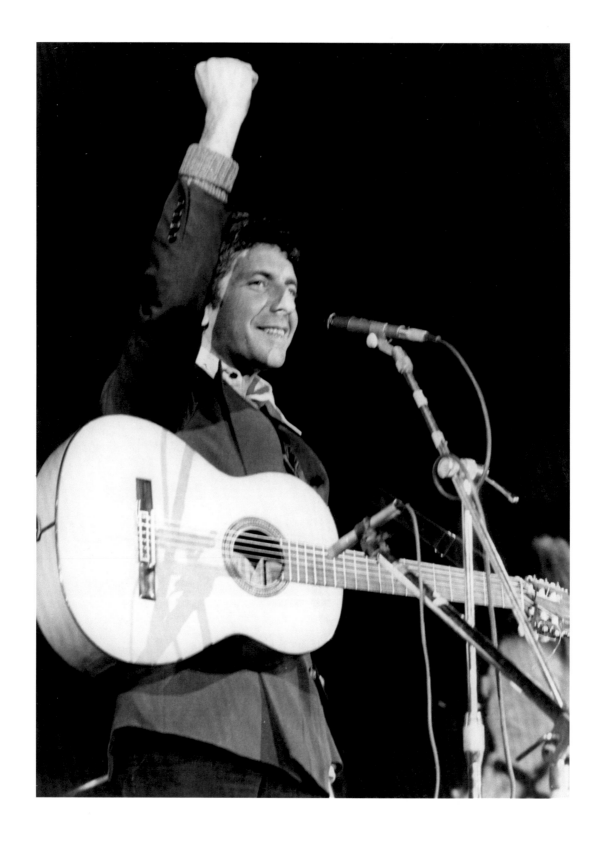

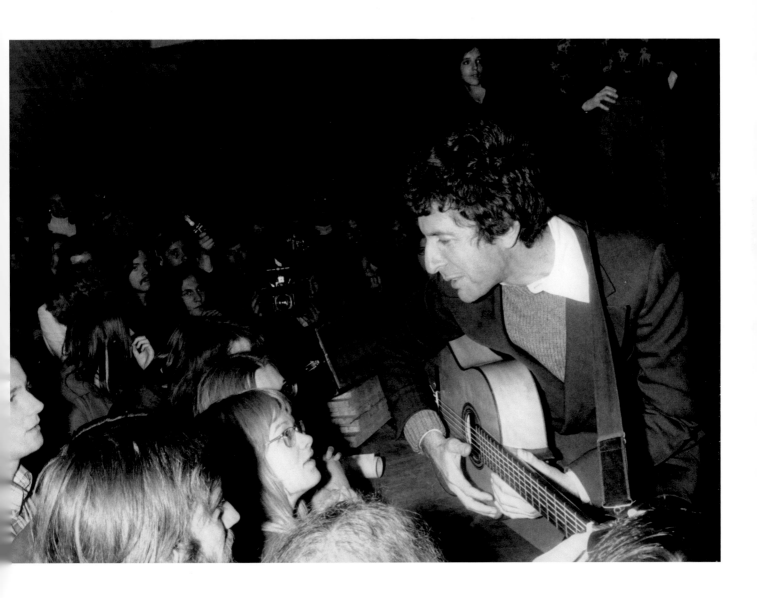

Getting up close and personal with the audience. Band member Ron Cornelius recalls a scene
in Hamburg in which Leonard jumped from the stage and kissed a young woman in the audience:
"It just went on and on and on. It ended up with Leonard on the floor, and you wondered if they were
going to start taking their clothes off now … He just lost it; he just got so sexually involved
with the crowd that he took it to a new level."

"Famous Blue Raincoat." Cohen bought the coat that inspired the song
at Burberry's during his first stay in London. He is seen wearing it here during
a photo session in Amsterdam in April 1972. Photos: Gijsbert Hanekroot

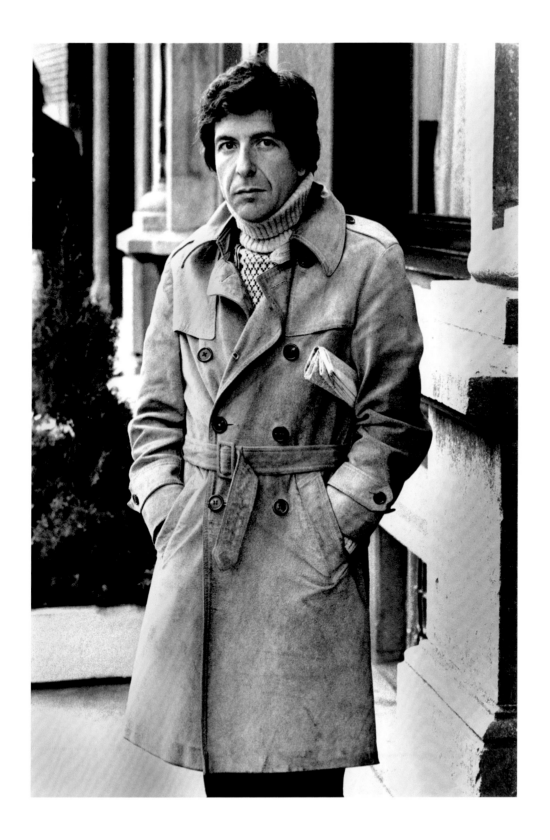

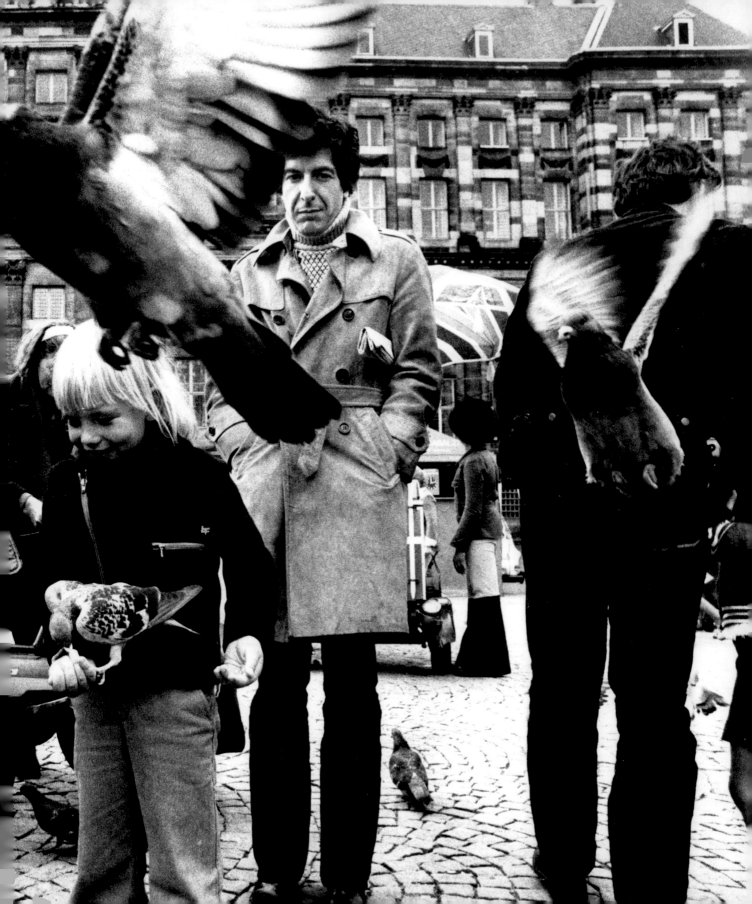

The contemplative artist backstage at the Hamburger Musikhalle.
Around this time, he spoke to a journalist about the corrupting influence of fame:
"One feels a sense of importance in one's heart that is absolutely fatal to the writing
of poetry. You can't feel important and write well." Photo: Hans-Jürgen Dibbert

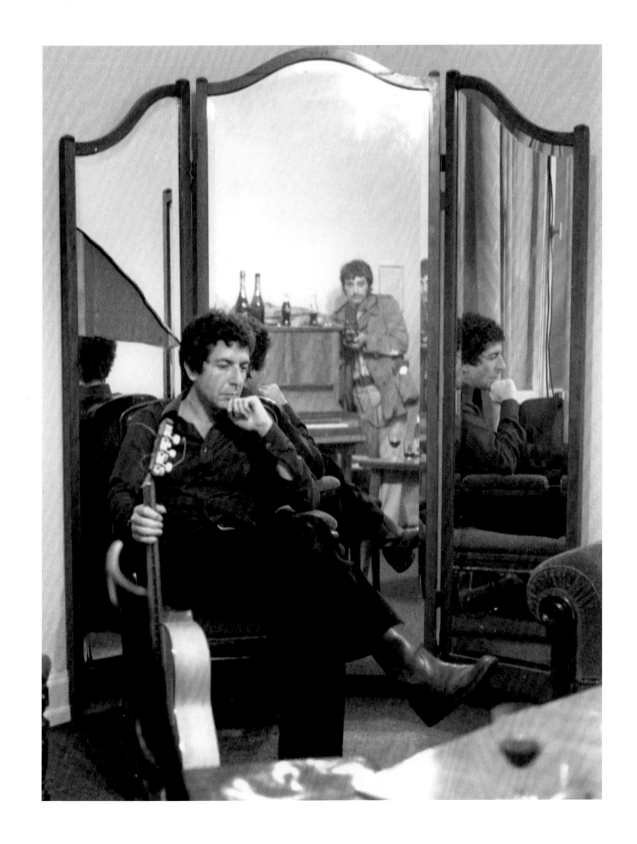

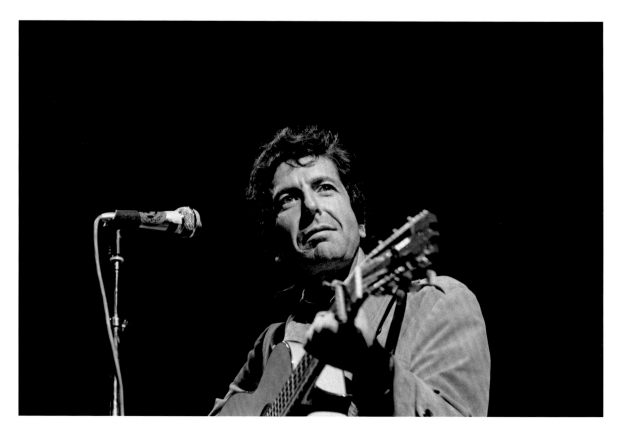

Performing at the Fête de L'Humanité 1974 in
La Courneuve, France. Photo: Guy Le Querrec

In October 1979, Leonard set off on a 51-concert European tour with a new band,
which included both oud and violin, in order to promote the *Recent Songs* album.
Band-member Roscoe Beck recalled: "It was world music before the term existed."
Cohen had been through a difficult period: his mother had passed away, the mother
of his children, Suzanne Elrod, had left him – and he had ventured
into the recording studio with the eccentric Phil Spector
for his album *Death of a Ladies' Man.* Photo: Ian Cook

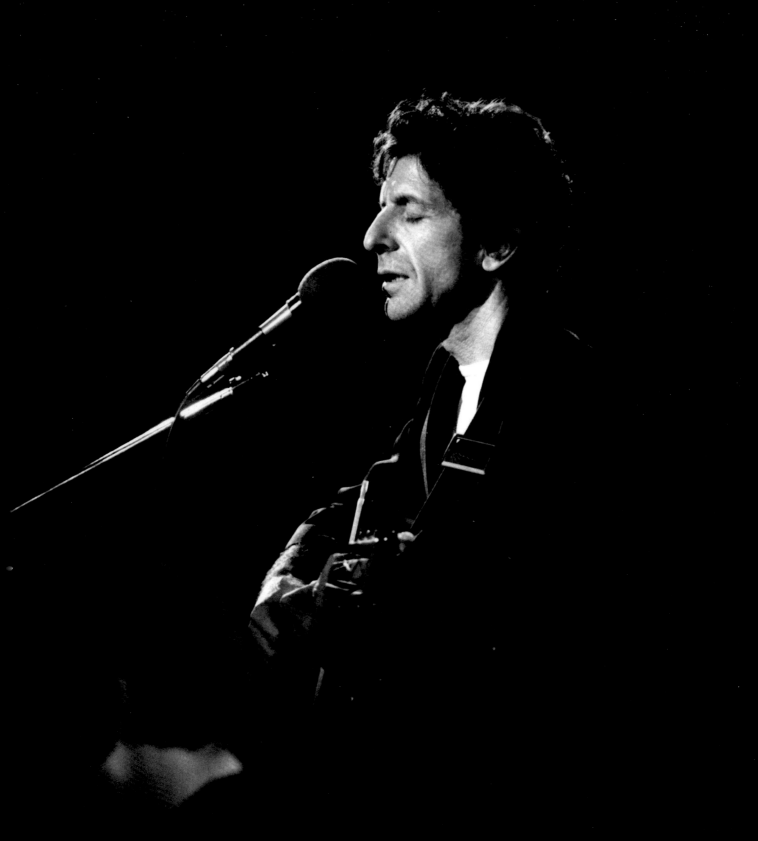

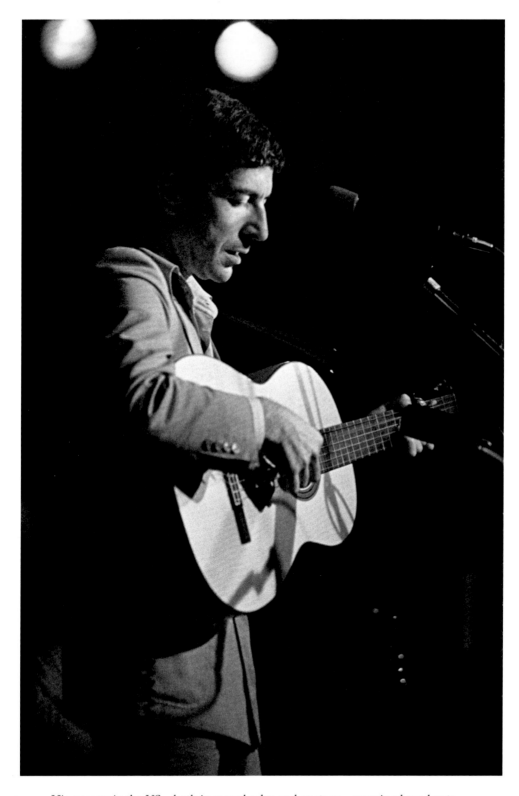

His success in the US – both in record sales and onstage – remained moderate …

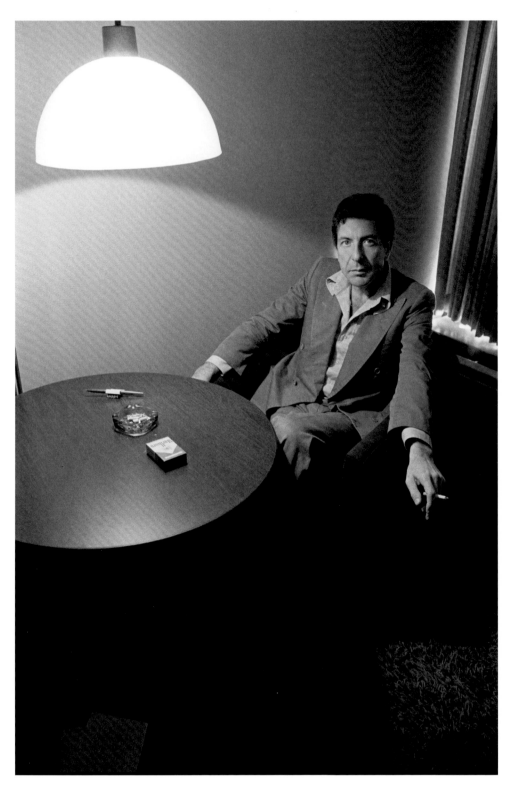

… seen here during a performance and interview in Atlanta, 1975. (Photo: Tom Hill) …

… while the Europeans, especially the British,
showered Leonard Cohen with undiminished praise.
A very relaxed Cohen in a London hotel, 1974
(Photo: Michael Putland) …

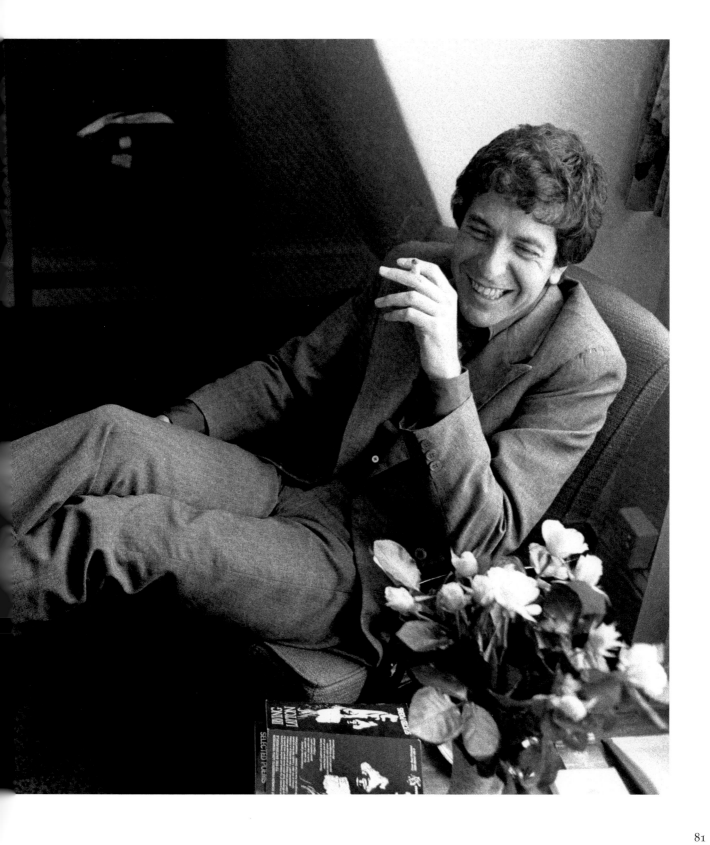

… and performing at the Hammersmith Odeon, London, in February 1979.
Photo: Terry Lott

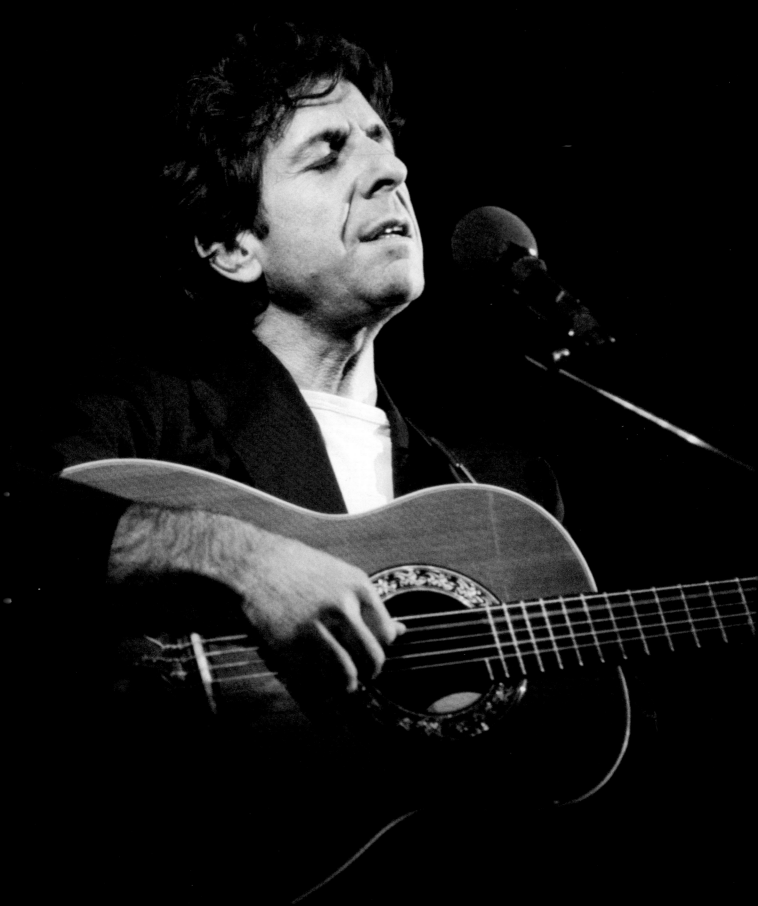

The photos on the right and on the following pages were taken by David Boswell
on 20 October 1978 during an interview for the weekly "Georgia Straight" in Vancouver, Canada.
In the course of his many European tours during the following years, Leonard Cohen is plagued by
a growing feeling that he would not be missed on the stage. In late 1989, he therefore decided to
withdraw from the music business indefinitely in order to focus on Zen meditation with
his master, Joshu Sasaki Roshi, and to write new books.

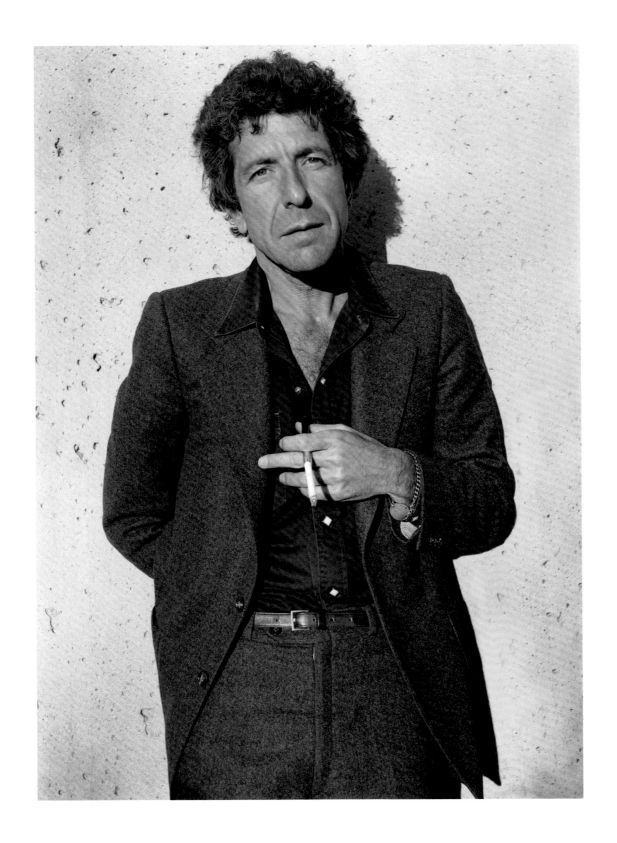

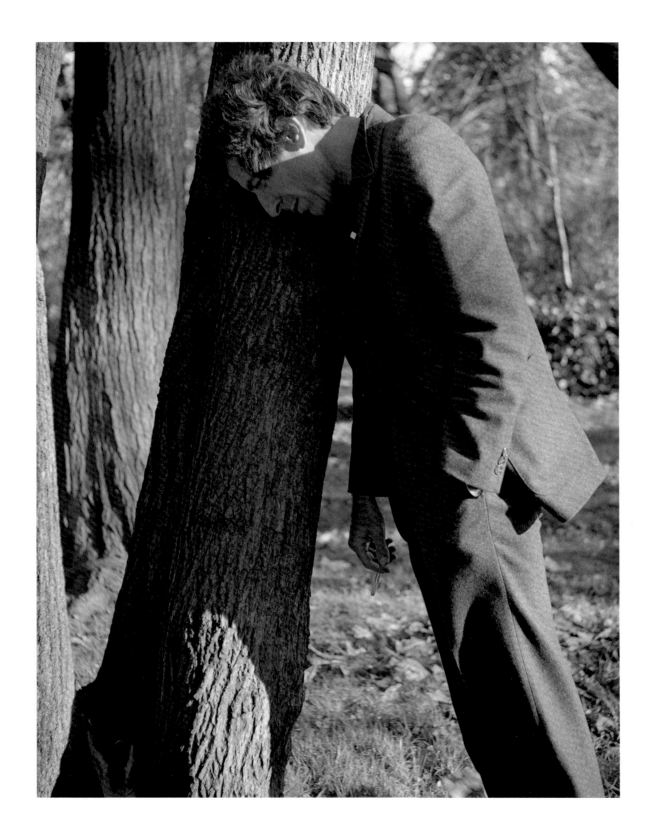

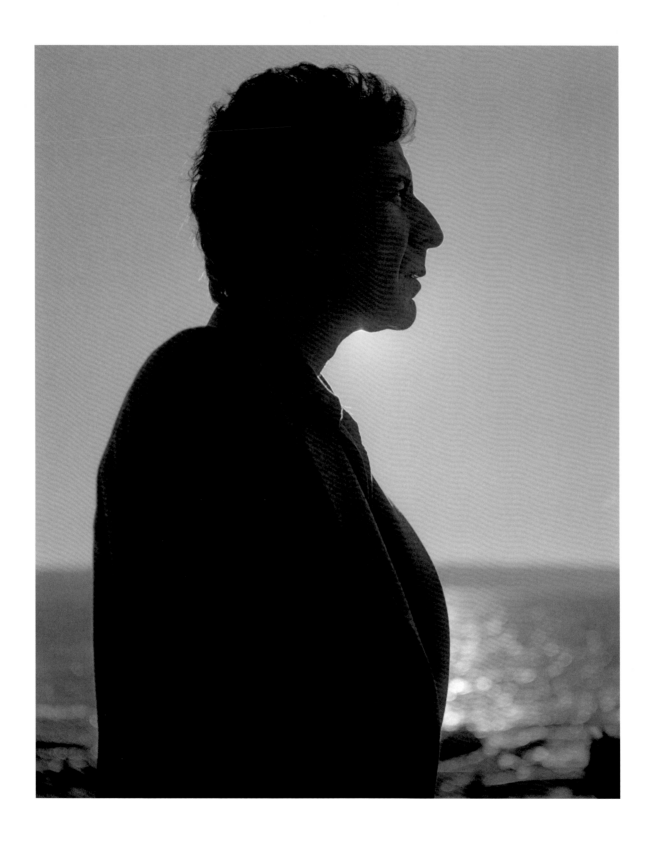

The 80s

Back on stage after four years: The realization that his lifestyle cost
him more than he earned – he supported Suzanne and the children, as well as
the Zen center and needy friends –, led Leonard back to the music world. In early 1985,
he went on tour with the album *Various Positions,* which included the hymns
"Hallelujah" and "If It Be Your Will," and also performed at the Salle Pleyel
in Paris. Photo: Thierry Orban

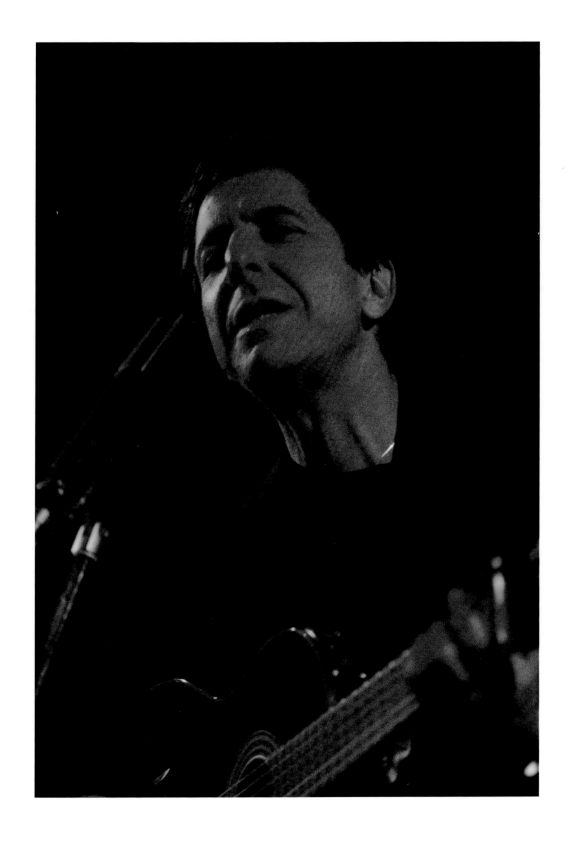

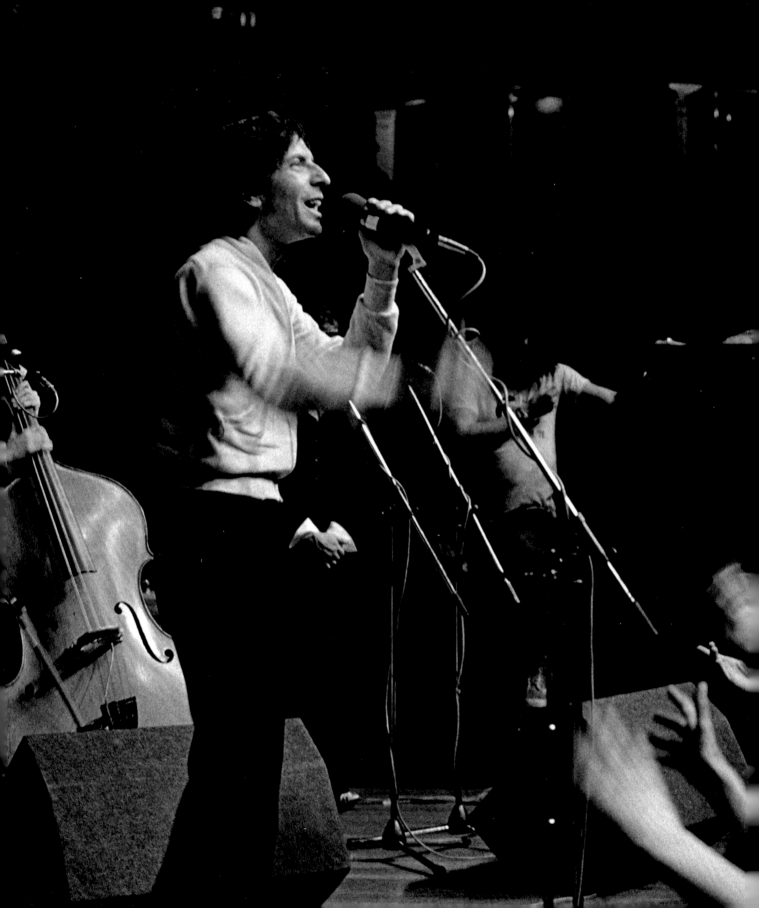

"Hallelujah! He's back!" An enthusiastic crowd greeted Leonard in February 1985 at the Hammersmith Odeon in London. Photo: Tom Sheehan

Alongside "Suzanne," the song "Hallelujah" is the most played and most covered song by Cohen. In writing it, he filled a book with stanzas for over five years; of those stanzas, he kept 80 and gave the ones he didn't use to other musicians. More than 300 artists, including no one less than Bob Dylan, have covered it.

The photos on the right and on the following pages were taken
in 1985 in a small recording studio in Manhattan, where the album
Various Positions was made. Photos: Oliver Morris

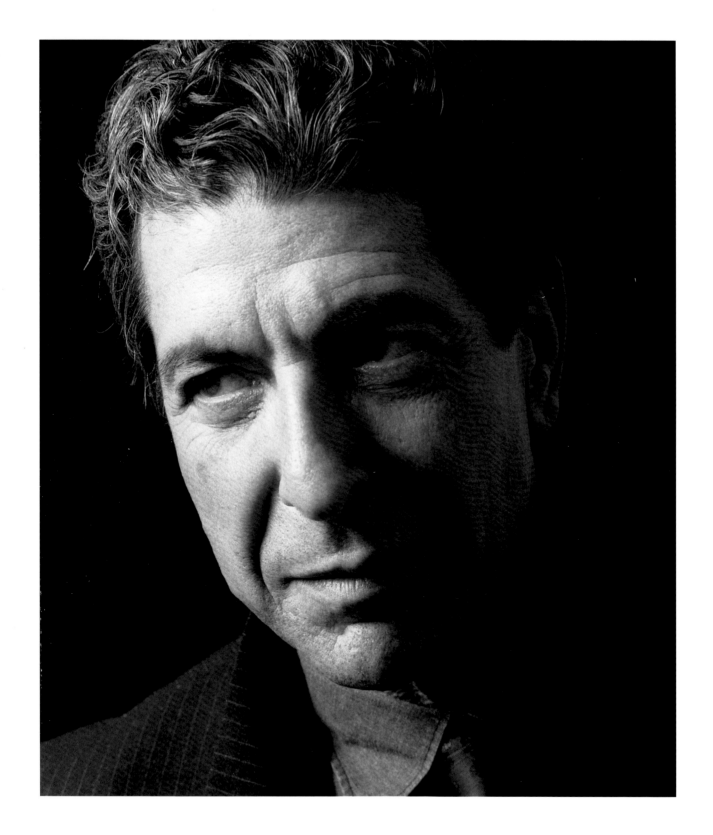

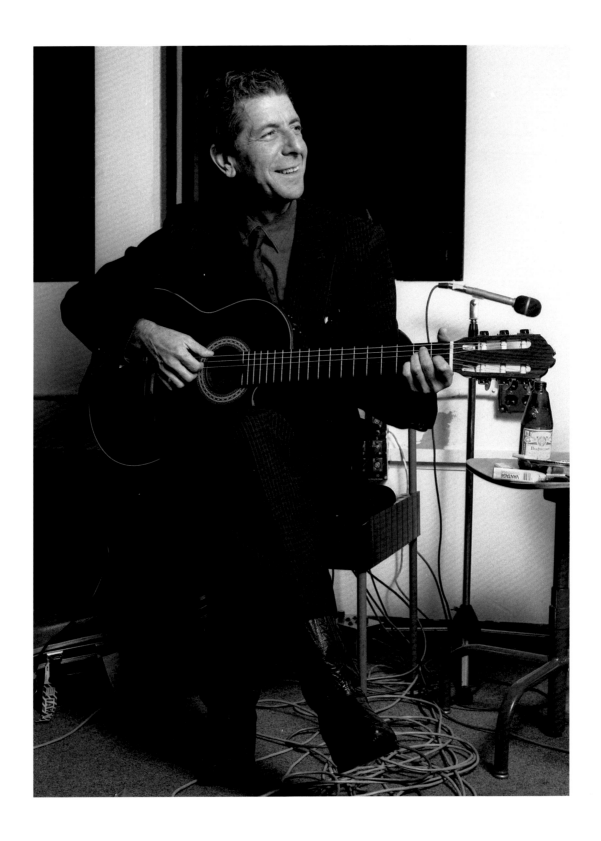

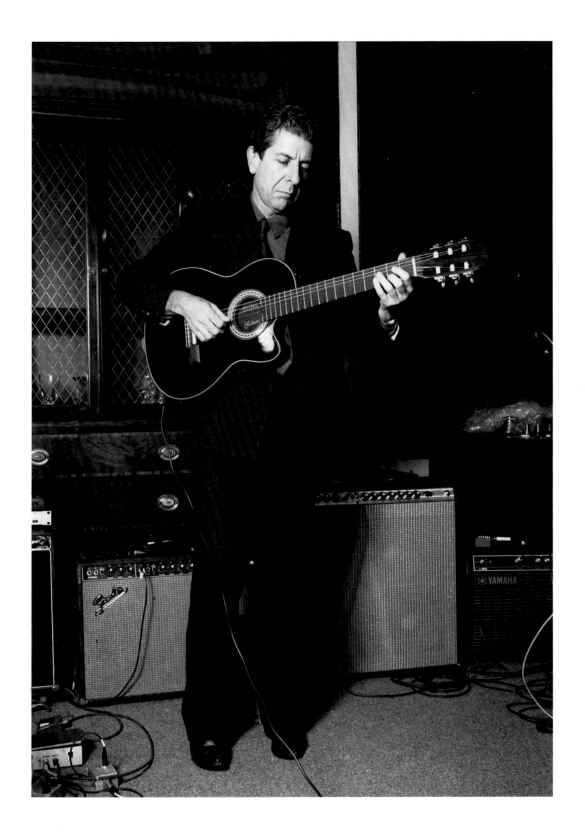

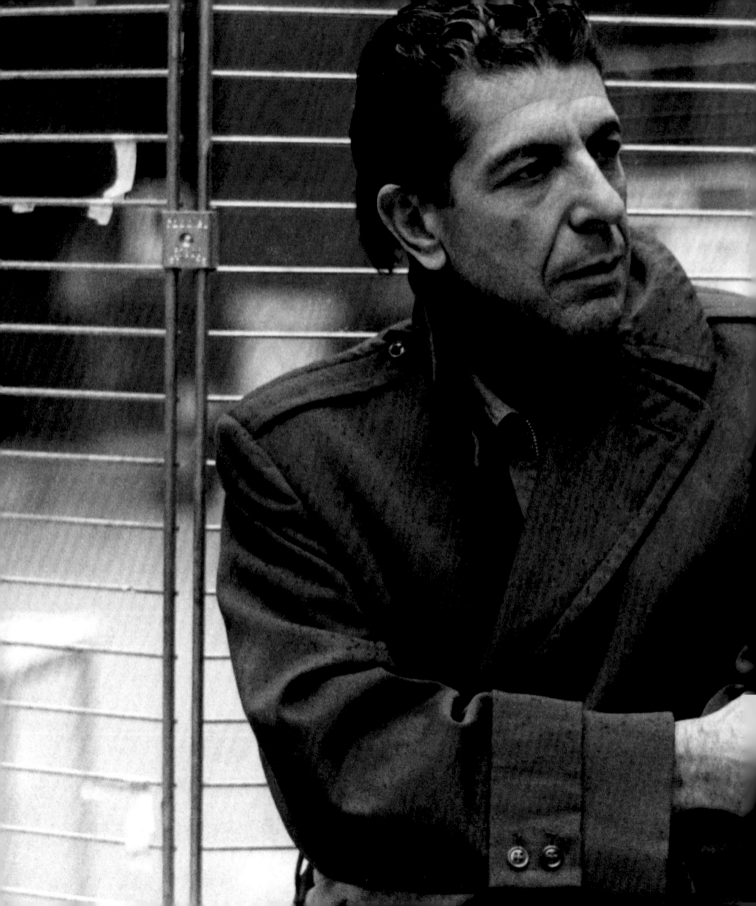

The master, shivering from the cold – neither the famous raincoat nor the cigarette are proof against it.
Photo: Frédéric Huijbregts

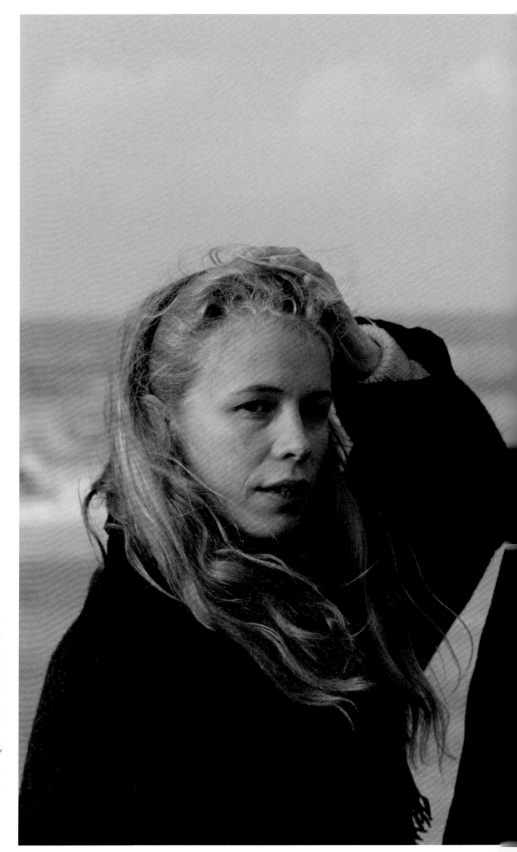

This and the following page:
With Dominique Issermann on the beach at Trouville, France. The French photo artist met Leonard in 1982 on Hydra, when mutual friends brought her along for a visit. These photos were taken by Eric Preau in 1988, while Issermann was shooting a music video for the song "First We Take Manhattan" from the album *I'm Your Man*. The album is dedicated to her.

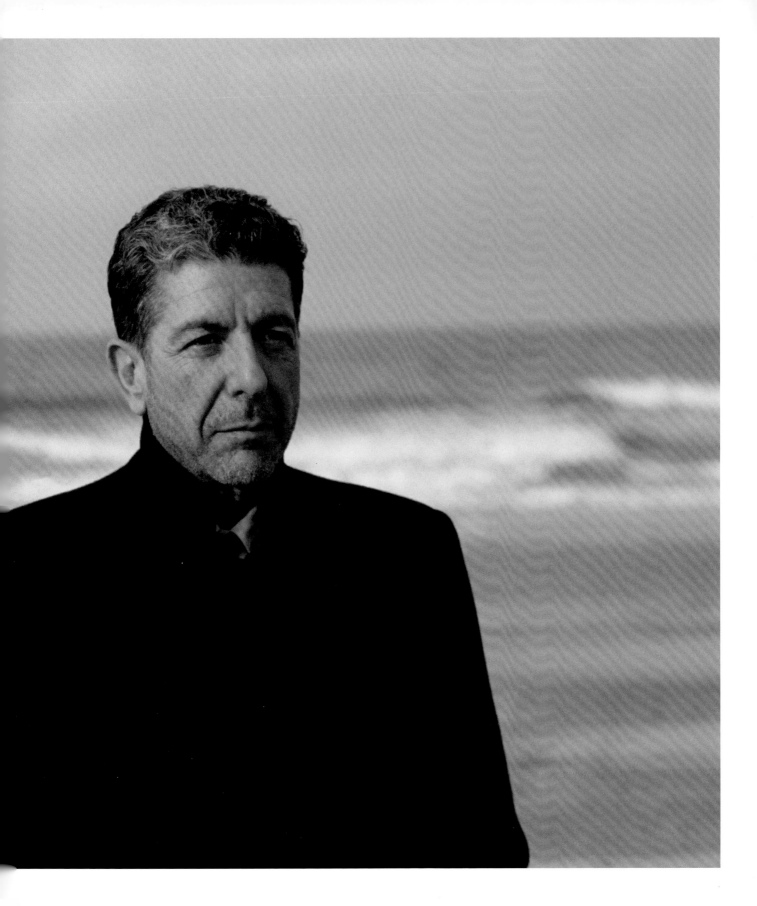

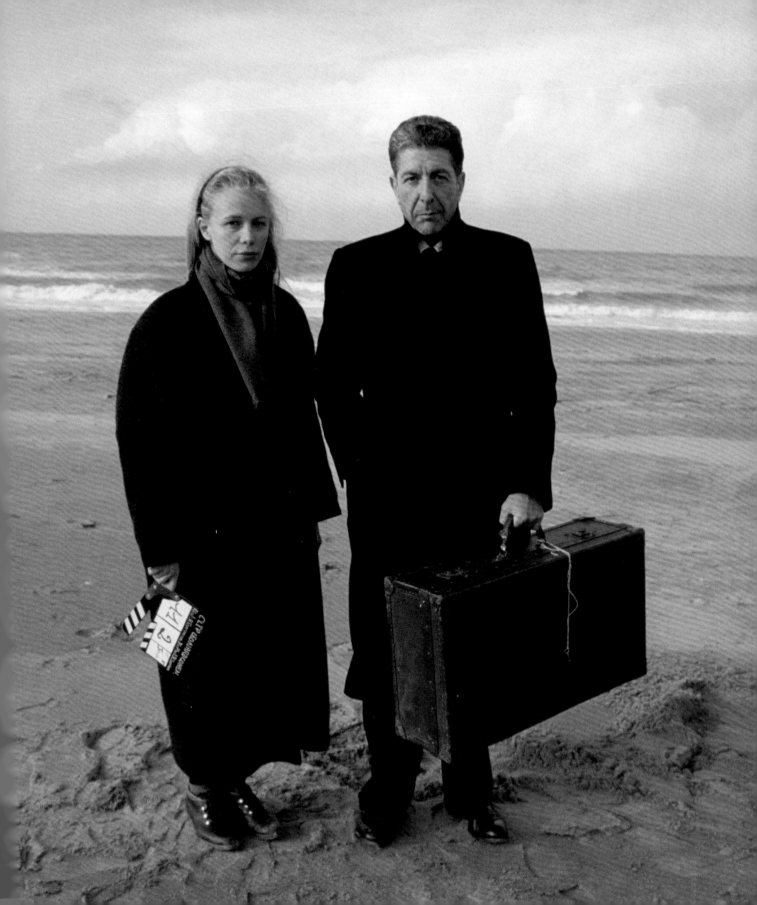

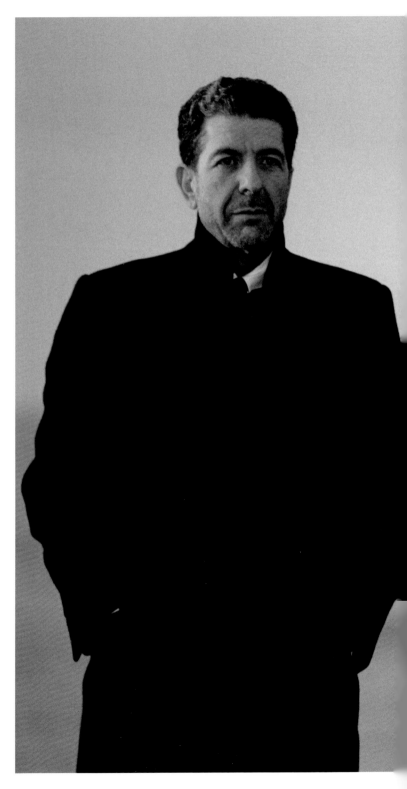

With Dominique Issermann
and an unnamed extra on
the beach at Trouville, 1988.
Photo: Bernard Barbereau.

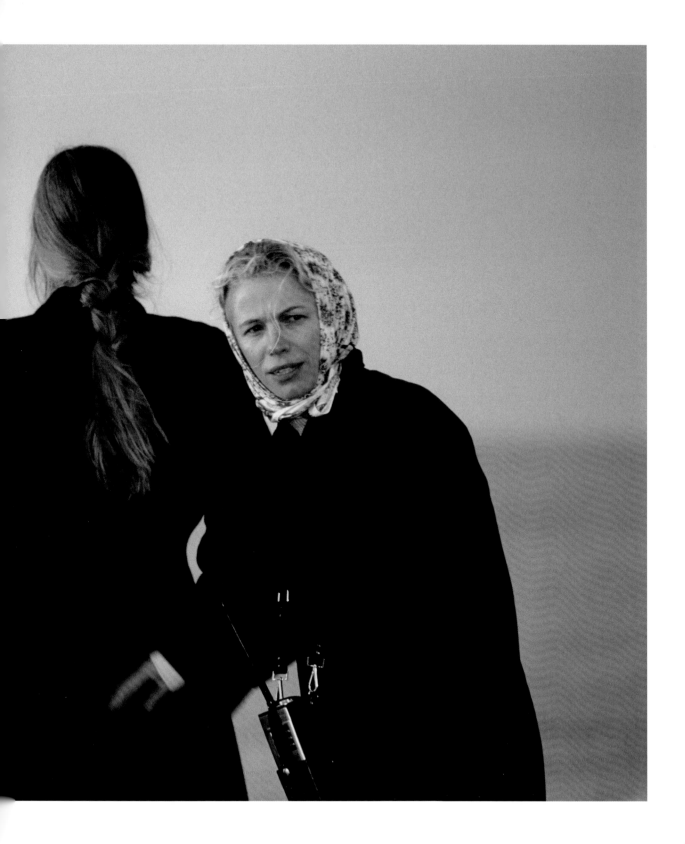

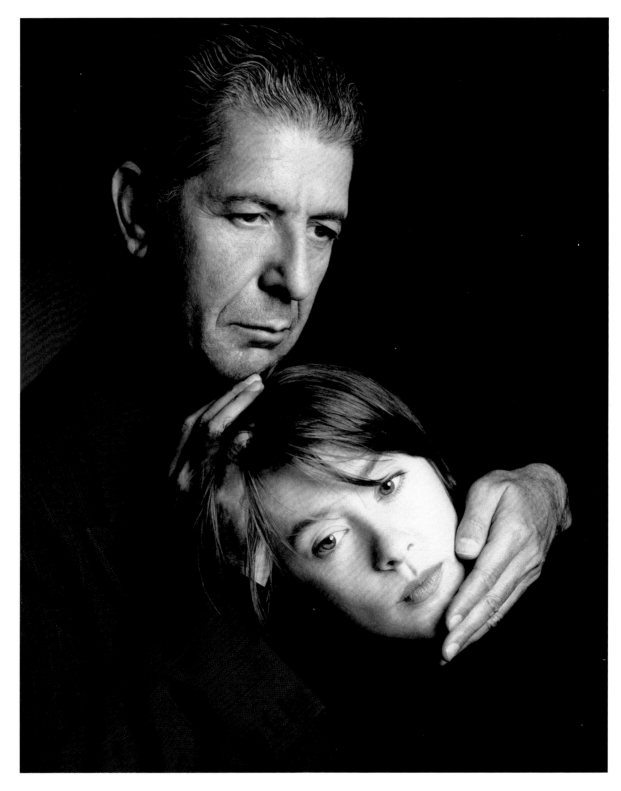

In 1989 with colleague Suzanne Vega, an avowed Cohen fan who would later appear on the 1995 tribute album *Tower Of Song*. Photo: Deborah Feingold

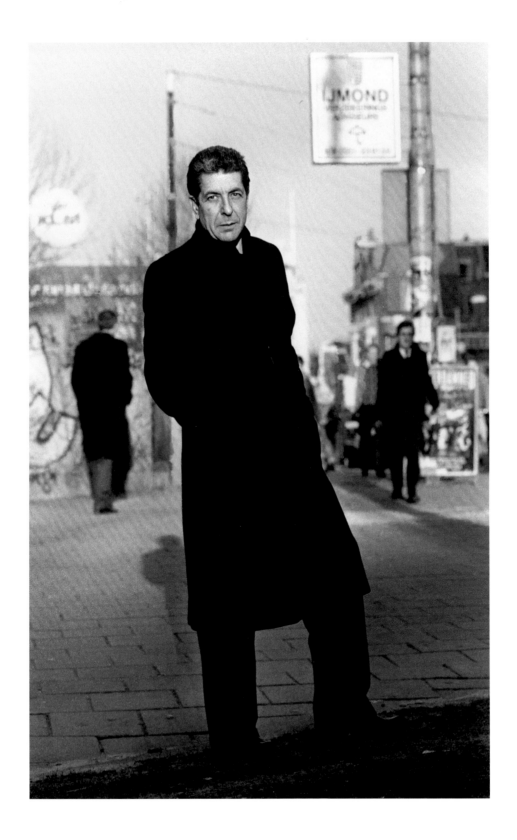

Previous page and right:
During a promotional tour for his most recent album in the Netherlands.
I'm Your Man "... rebranded Leonard, not least among younger fans, from dark, tortured
poet to officially cool," notes his biographer Sylvie Simmons. Photos: Rob Verhorst

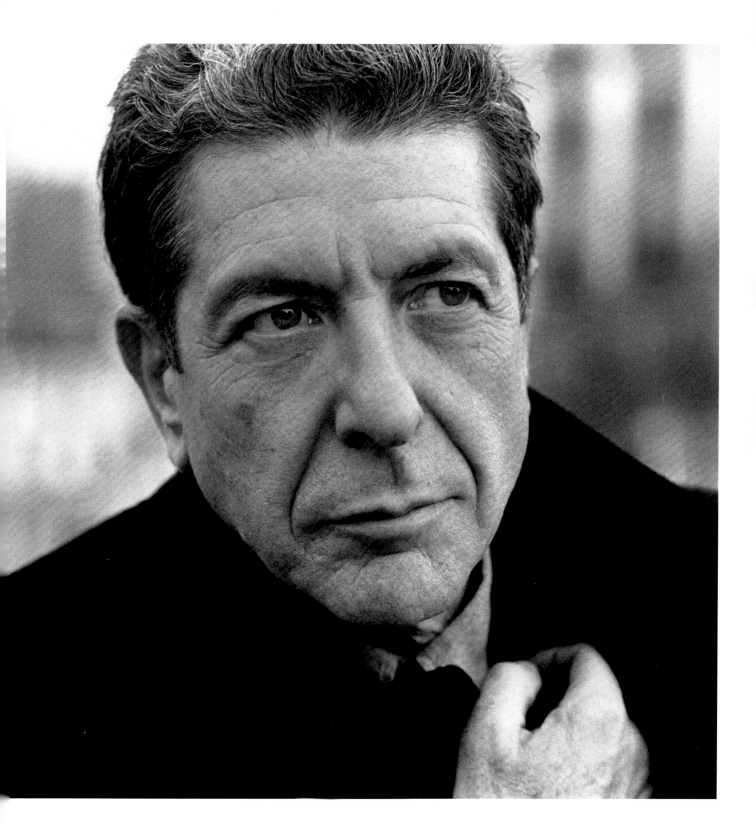

The 90s

In 1993 Leonard Cohen took the album *The Future* on tour and
enjoyed great success, not just during his two performance in the Netherlands
(photo: Rob Verhorst), but everywhere in Europe and in the US as well.

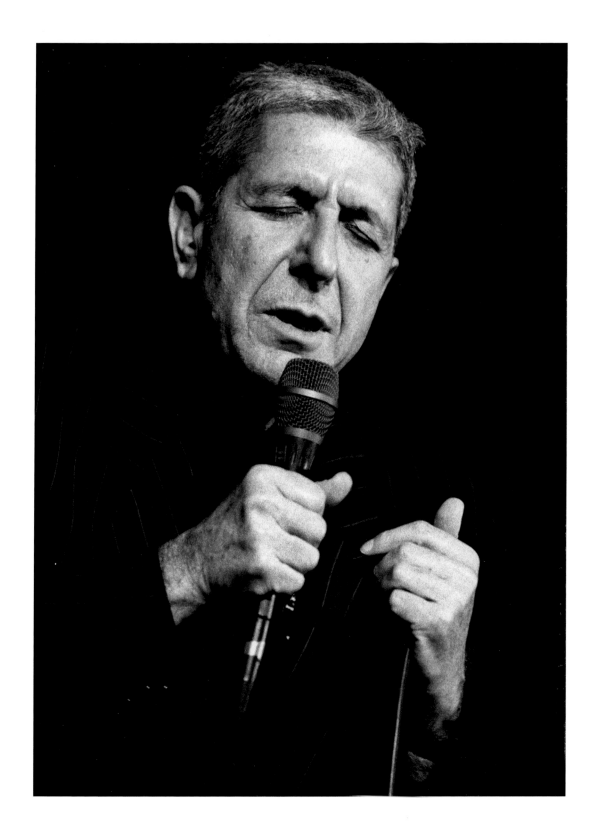

Too much fame: Back in Canada, Cohen had been inducted into the Hall of Fame,
McGill University awarded him an honorary doctorate, and he received the Governor General's
Performing Arts Award for Lifetime Artistic Achievement – but Leonard fled from all things worldly and
returned to the Zen monastery run by his friend Roshi on Mount Baldy near Los Angeles. He informs his
producer, Roscoe Beck, that he has"had it with this music racket."After three years in the monastery,
Cohen is ordained as a Buddhist monk in August 1996 and is given the name Jikan,
which loosely translated means"Silence."Photo: Neal Preston

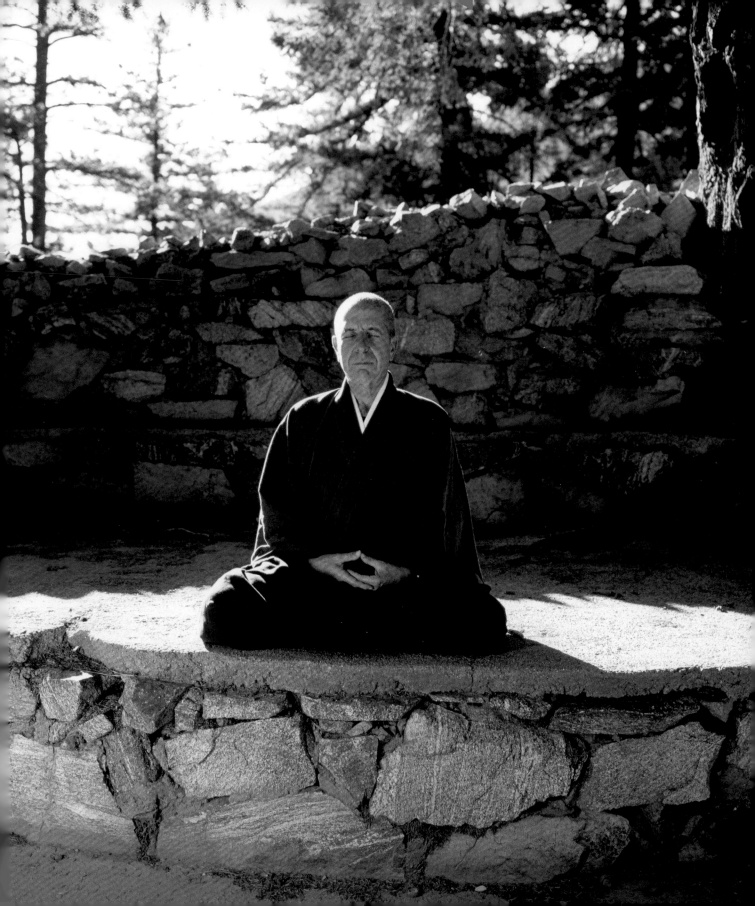

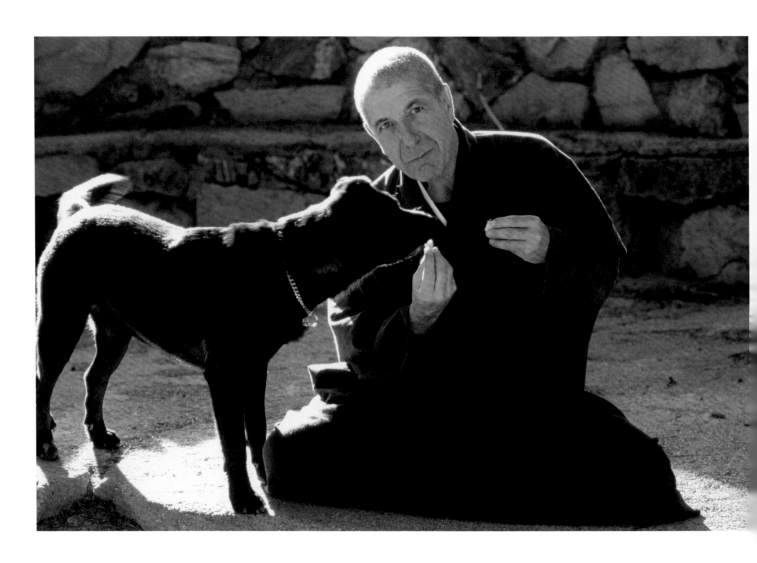

"...that's the predicament of people here. They have lots of questions in their heads but no answers. So, I think if I may be guilty of an oversimplification, what matters is to work to dissolve the questions rather than defining the answers so you want to produce a mind which is free of all these questions."
(Cohen in a radio interview with France-Inter)

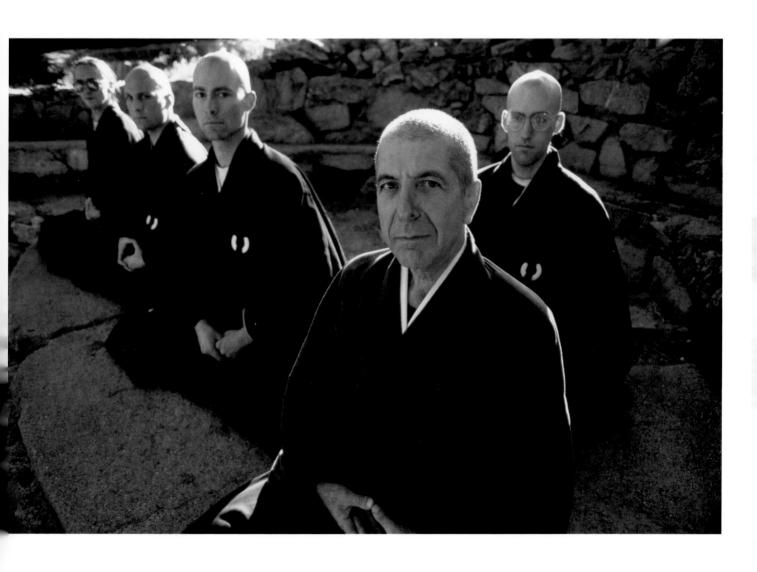

Leonard Cohen lived on Mount Baldy for over five years and enjoyed no special privileges, aside from having a synthesizer, which he used for songwriting, and being able to spend quite a lot of time with Master Roshi due to the fact that he acted as his personal chef and chauffeur.
Photos: Neal Preston

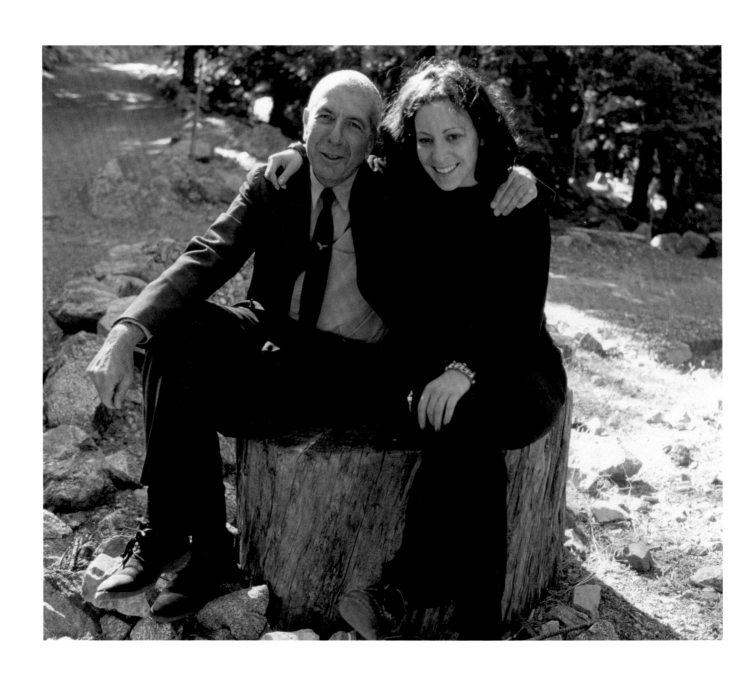

Family reunion: Leonard with daughter Lorca at the Zen center in 1995, . . .
Photo: Neal Preston

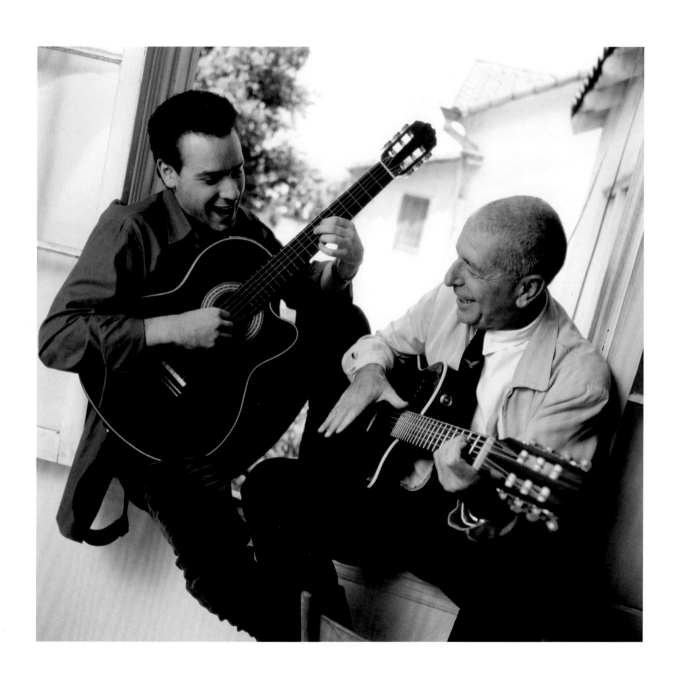

… and with son Adam, who followed in his father's footsteps
and signed a recording contract with Columbia.
Photo: Gary Moss

Late Comeback

Back in the music scene: After five years on Mount Baldy and a year in India with a Hindu teacher,
Leonard tells his producer Roscoe Beck: "Ah, now I've had it with the religious racket.
I'm ready to take up music again."

In 2001 he records a new album in the studio above his garage in LA.
And the gangster hat becomes his new trademark. He completes his wardrobe with
a suit and tie in the style of his paternal ancestors. Photo: Ethan Hill

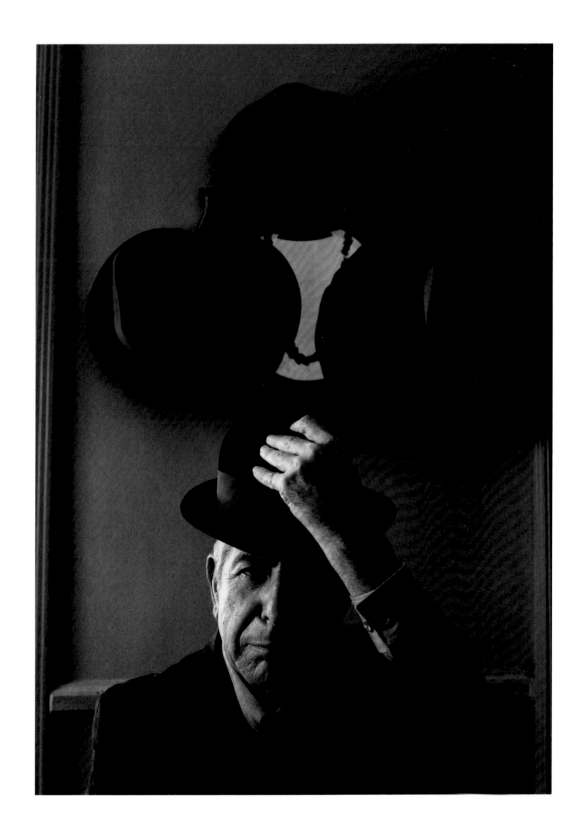

This portrait from the series by Mitch Jenkins was taken in London in October 2001, the month in which *Ten New Songs*, his first album in eight years, was released.

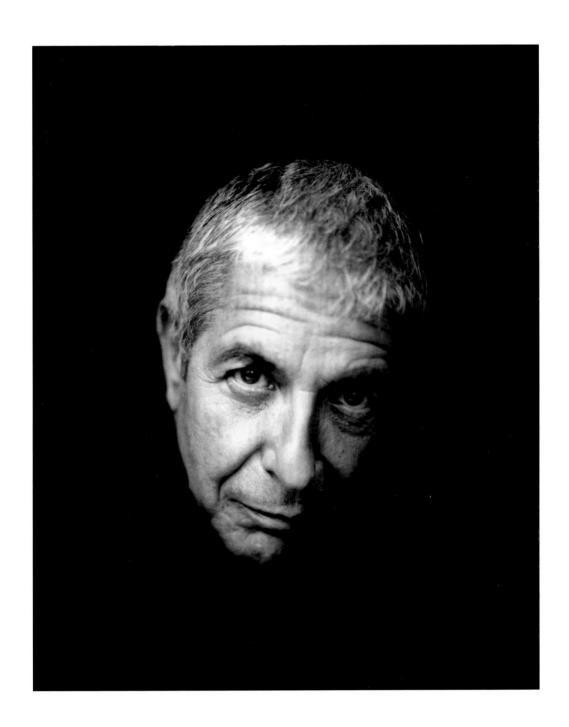

In March 2008 Leonard Cohen was inducted into the
Rock and Roll Hall of Fame in New York.
Photo: Kevin Kane

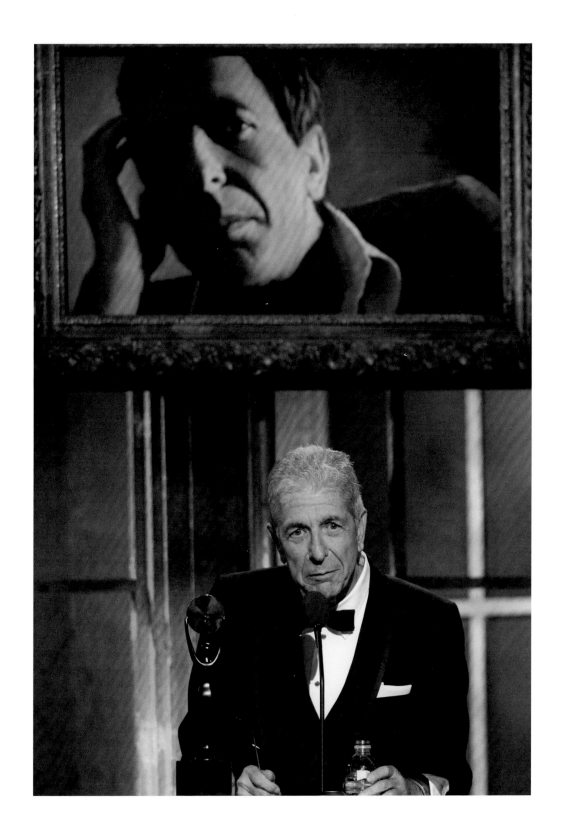

"First we take Fredericton, then we take Berlin." In October 2004 Leonard Cohen learned that his manager had pilfered millions from him and that he was nearly broke. Only reluctantly did he consider going on tour in order to refill his coffers. But his fears of making a fool of himself by playing to half-empty venues are unfounded. Following a few dry runs in the Canadian outback, including Fredericton, the tour officially gets underway in May. Due to its overwhelming success, it is extended time and again and covers the entire globe in several legs until December 2010. He is seen here in June 2008, during one of the first concerts in Europe, at the Glastonbury Festival in Somerset, England, which was attended by 100,000 fans. Photo: Luke MacGregor

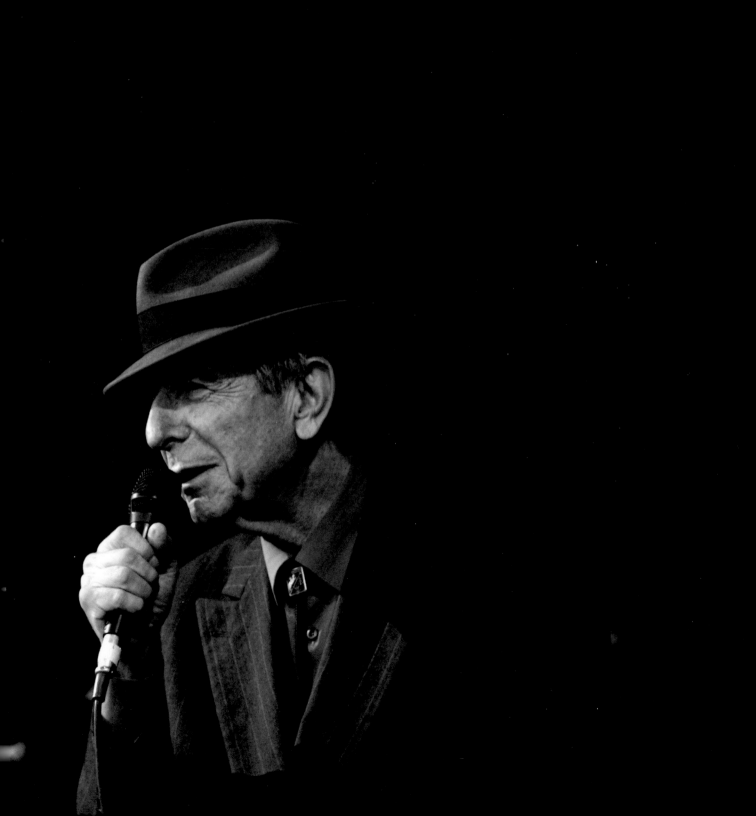

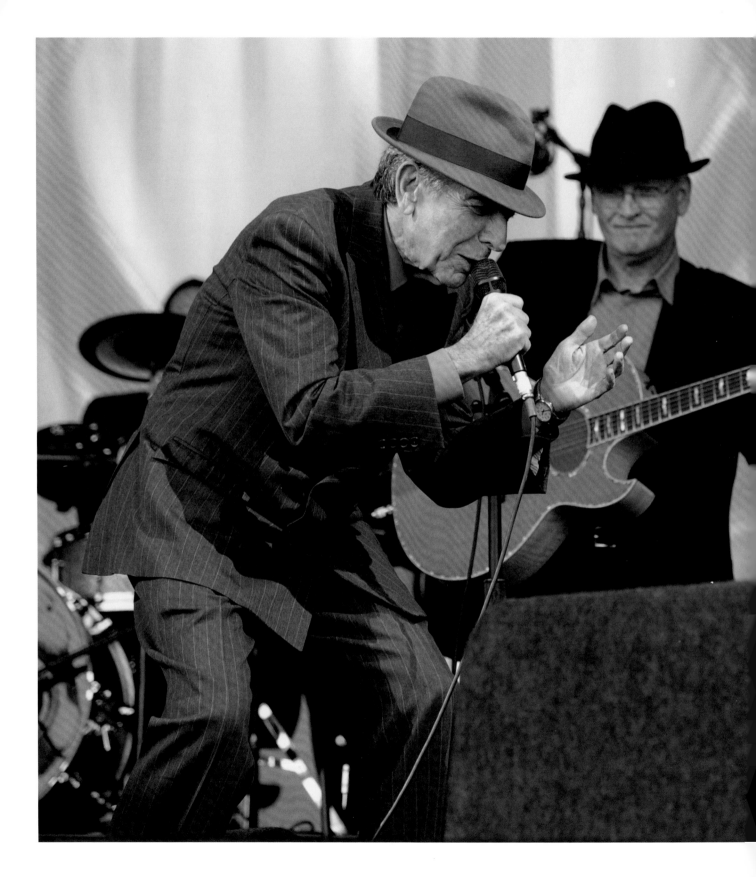

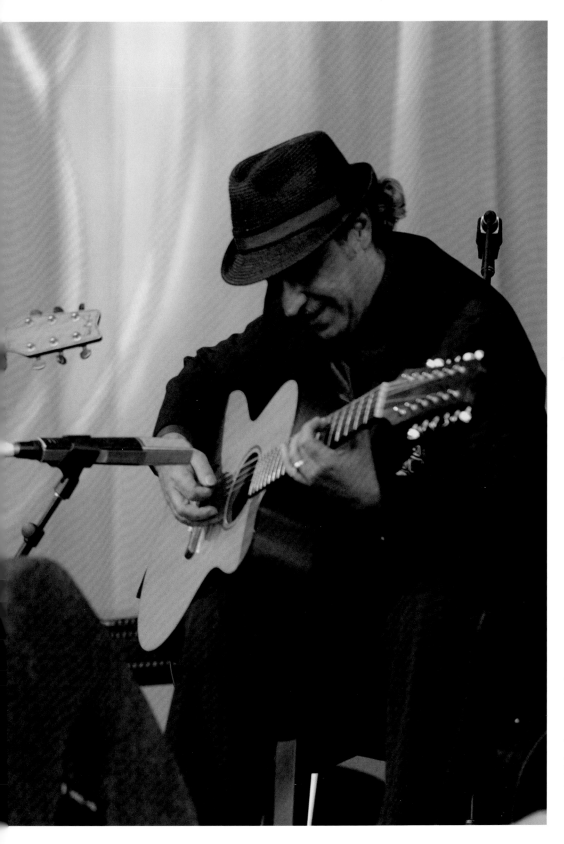

World music in Glastonbury: Leonard with his regular guitarist, Bob Metzger (center), and a new addition from Barcelona, Javier Mas, who plays bandurria, lute, and twelve-string guitar.
Photo: Rune Hellestad

Radiant and relaxed. He tells his audience that the last time he stood on the stage he was "60 years old, just a kid with a crazy dream." He never hoped to imagine that he could still win hearts at 73.
Photo: Ben Stansall

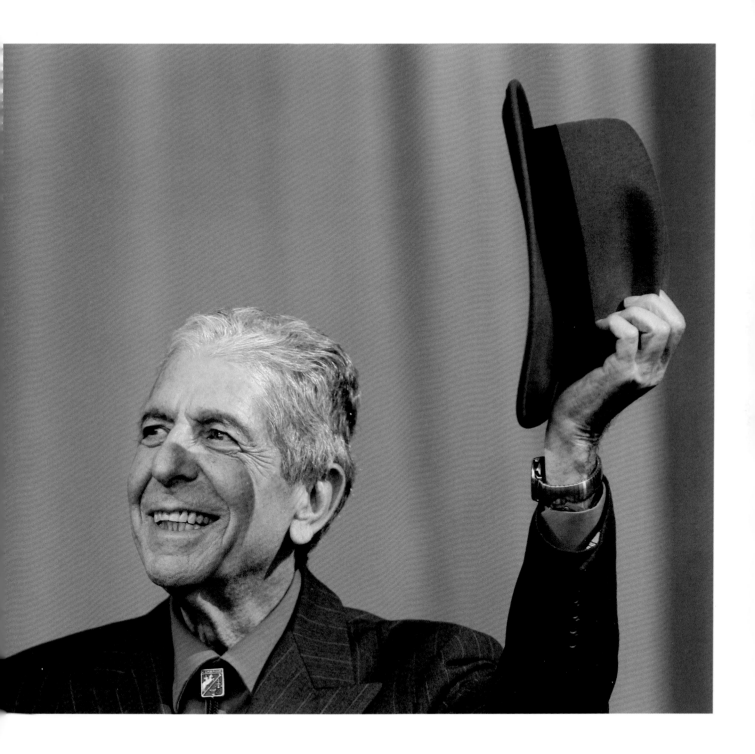

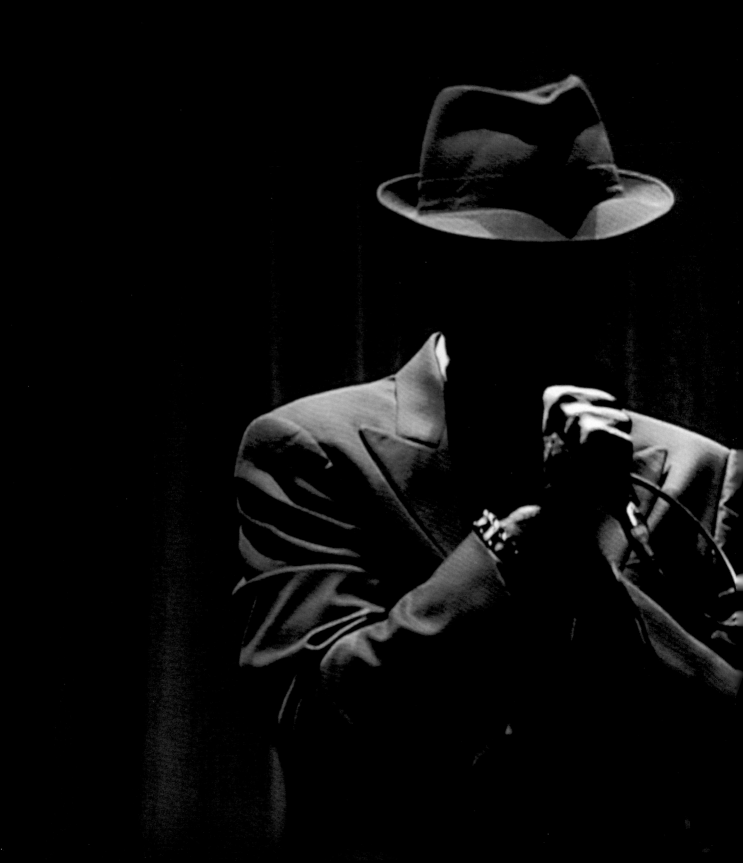

Left and following pages:
Three hours onstage, every night –
here at the Schleyer-Halle in
Stuttgart on 1 October 2010.
Photos: Sibylle Nottebohm

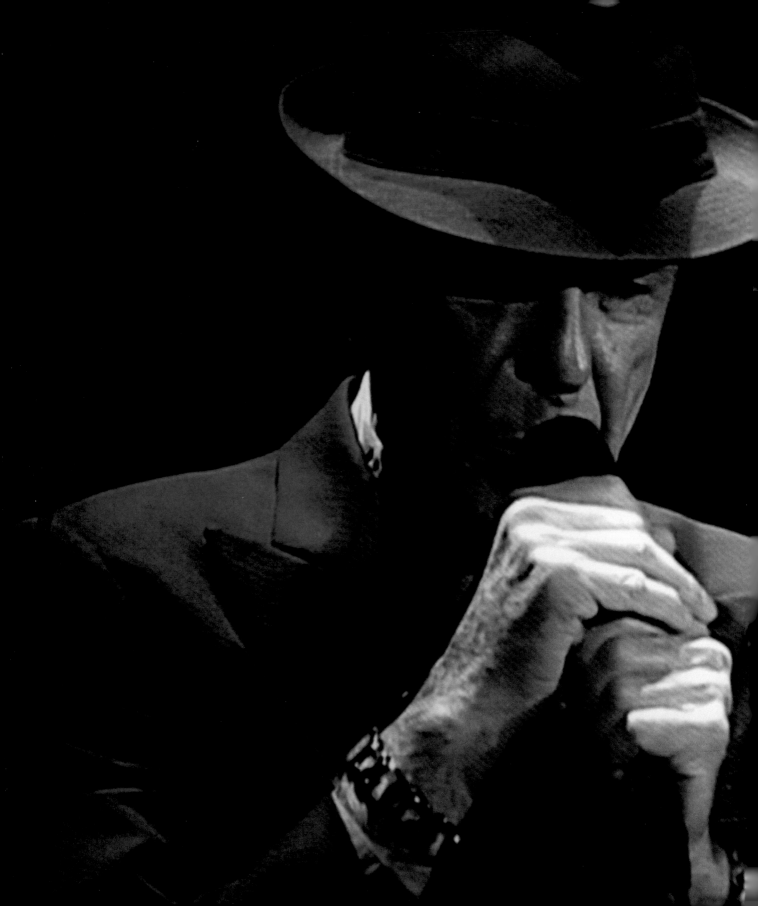

On 21 October 2011, Leonard Cohen received the Prince of Asturias Award
for Literature in Oviedo, Spain. He is seen here en route to the award ceremony
at Campoamor Theatre. Photo: Carlos Alvarez

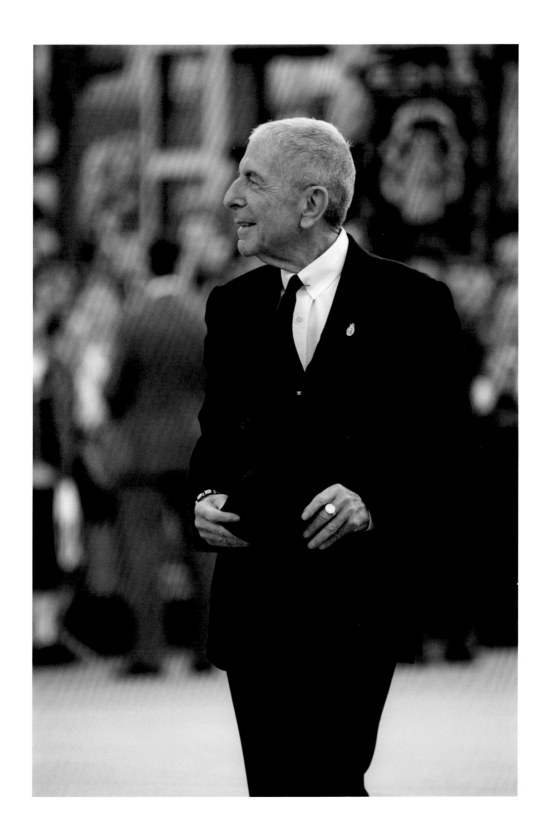

In his acceptance speech for the prestigious award, Cohen stressed his great attachment
to Spanish culture: not only was his Conde guitar made of native cedarwood by a Spanish guitar maker,
his first non-English literary inspiration came from a Spaniard – Federico Garcia Lorca. And, last
but not least, his skill on the guitar was based on the six Flamenco chords he learned
early on from a young Spaniard in Montreal. Photo: Jack Abuin

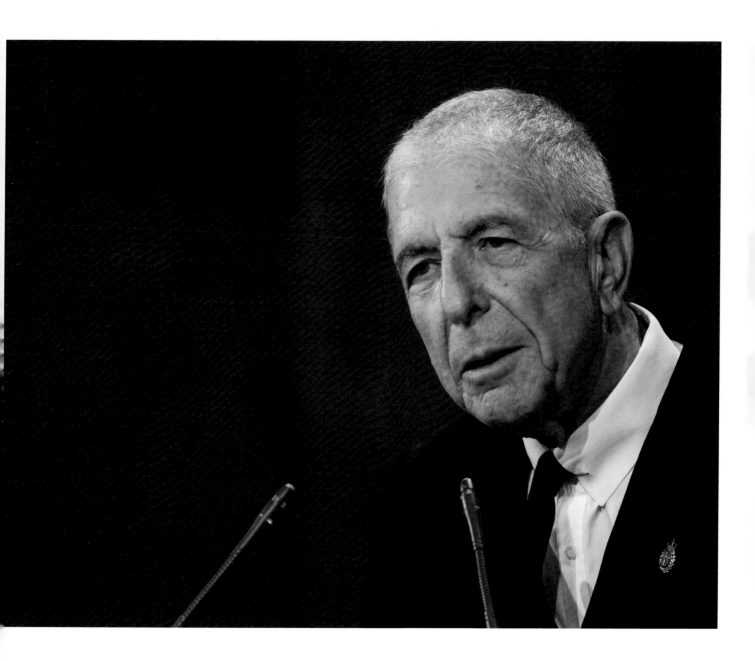

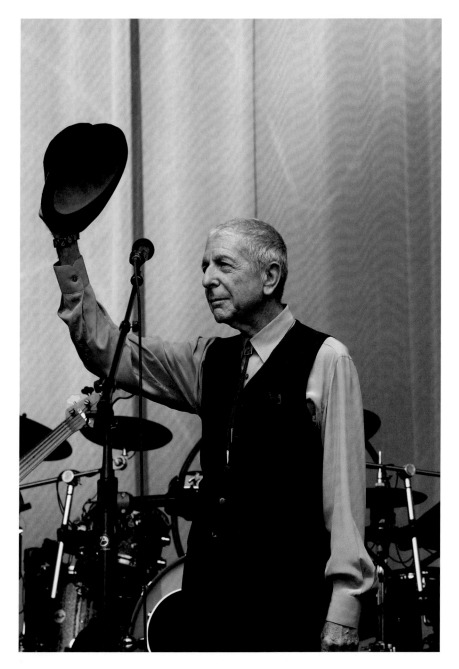

As soon as he got back to his home studio, Cohen recorded the songs
he had written during the protracted tour and released his next album, *Old Ideas*,
before he hit the road again. He is seen here during a concert in Ghent, Belgium.
This European tour, which kicked off in March 2012, would later morph
into a world tour. Photo: Nicolas Maeterlinck

Left: Leonard out of the spotlight and on the keyboard during a performance
at the Beacon Theatre in New York, February 2009. Photo: Michael Loccisano

"He's a lazy bastard living in a suit," is how Leonard Cohen describes himself in the song "Going Home." It is wonderfully self-ironic in view of the fact that, at the time, he was "the hardest-working man in show business." Photo: Alex Sturrock

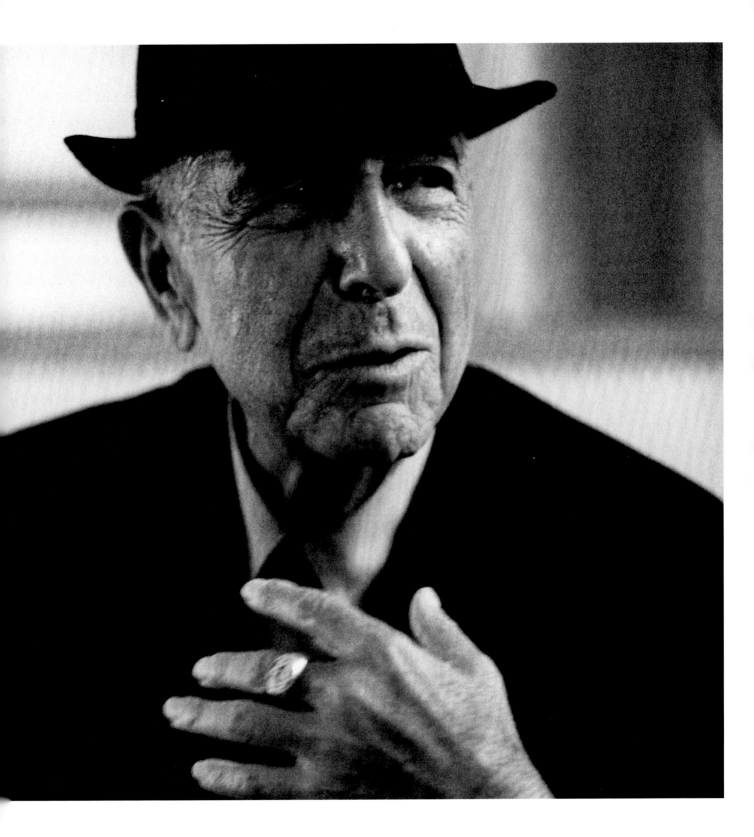

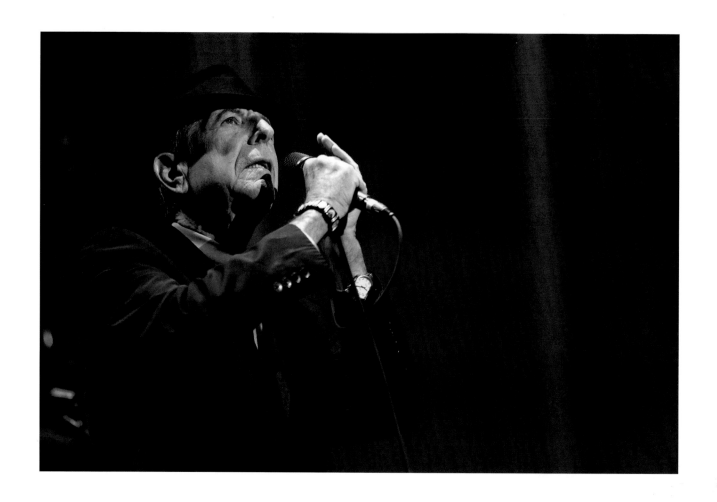

When he takes the microphone firmly in both hands – as seen here during a concert
at the Olympia in Paris in 2012 –, it is a signal for the musicians to play more softly in order to
give Leonard's voice more room. "We called ourselves the world's quietest band or at least the
quietest with electric instruments," remarked producer Roscoe Beck.
Photo: Thomas Samson

Bended knees and dance interludes: a soon-to-be octogenarian singer who comes skipping onto
the stage like a youthful show master: Leonard's audiences are amazed by the physical fitness he displays
in gigs lasting many hours, like here in Austin, Texas, on 31 October 2012.
Photo: Gary Miller

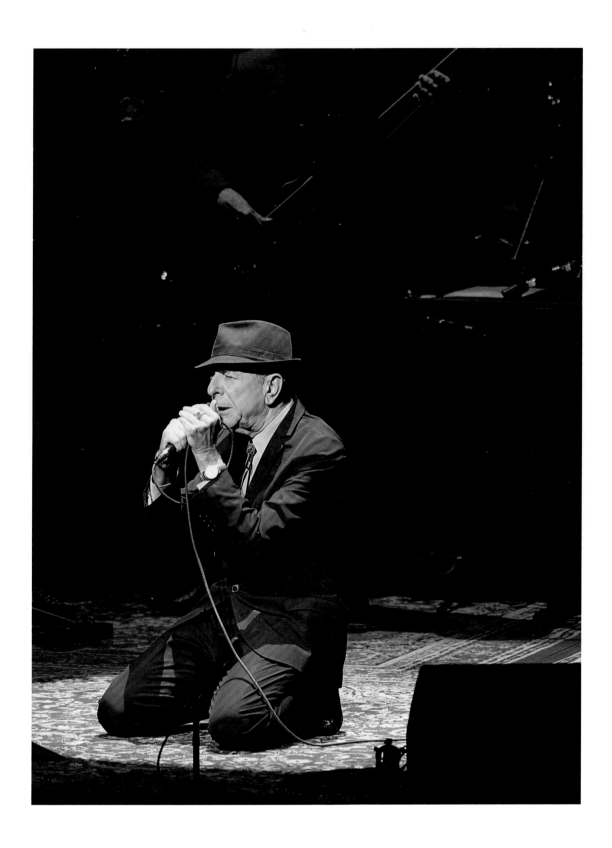

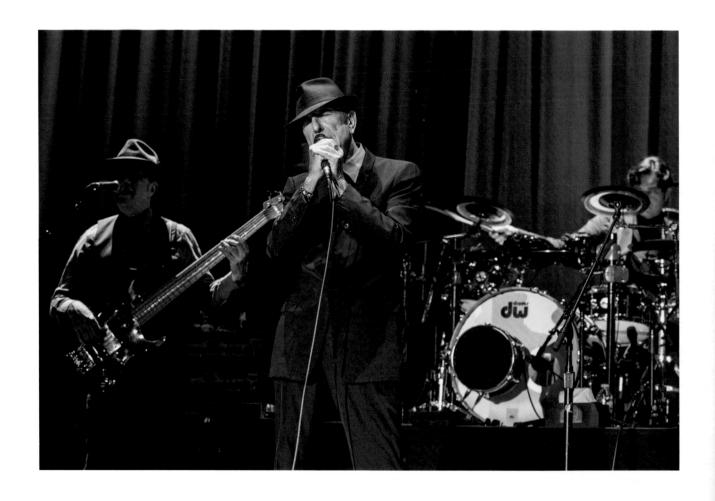

Where the present and future merge: while traveling with hand-picked musicians
like Javier Mas and Alexandru Bublitchi, new songs are born, some of which are tried out
on the road or are later recorded in the studio above his garage. The result: hopefully a new album
that Leonard will take on tour at age 80! Photos from the *Old Ideas* world tour:
David Wolff-Patrick (above, Paris, June 2013) and Tim Mosenfelder
(right, Austin, Texas, November 2012)

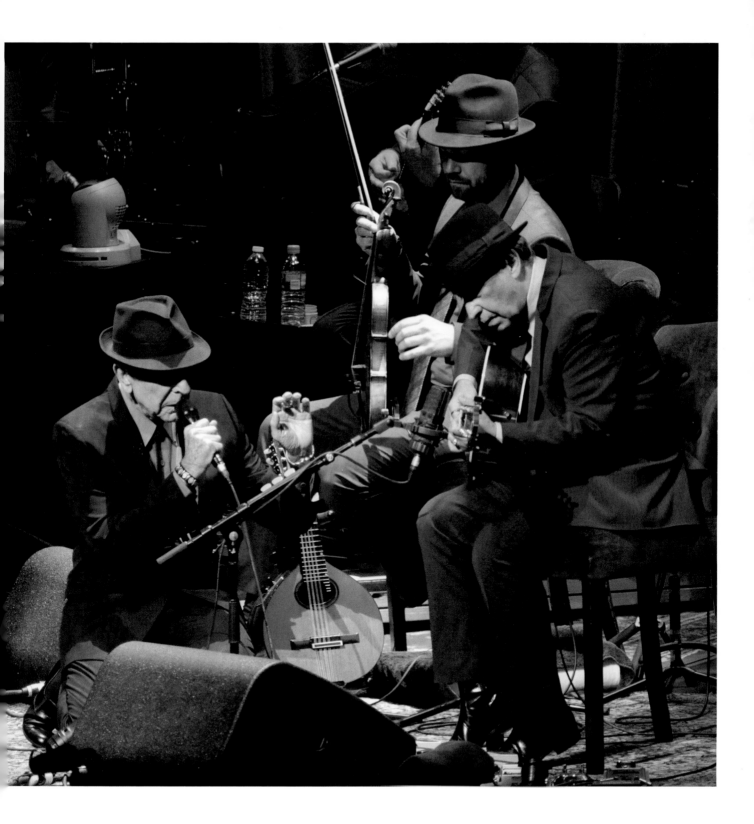

Appendix

Biography

21 September 1934: Leonard Norman Cohen is born in Montreal. He is the son of Nathaniel Bernard Cohen (born 1887), who runs a family-owned textile business, and Masha Cohen (nee Klonitzki-Kline, born 1907). His family background is conservative, affluent upper middle class, and strongly influenced by its Jewish roots. His family lives in Westmount, one of Montreal's "better" neighborhoods. His paternal side was second-generation Canadian (having originally immigrated from Lithuania), while Masha Klein had only arrived in 1923 after fleeing persecution in Eastern Europe with her parents.

January 1944: Leonard's father dies. Leonard is only nine, but as the only male heir, he soon finds himself in the role of the head of the household. While in primary school, he also attends the Hebrew school, where some bible lessons are also given in Hebrew.

1949: 15-year-old Cohen discovers the works of Federico Garcia Lorca, whose style will influence him.

1950: He begins writing poems of his own.

In addition to taking piano and guitar lessons, he also plays the clarinet in his high school band. In **1951** he forms a trio named "The Buckskin Boys," a country and western band. He plays an electric rhythm guitar and gathers his first stage experience. The band breaks up in 1954.

21 September 1951: He enrolls at McGill University in Montreal: one year of liberal arts, then a year of economics, then another two years of liberal arts.

1954: Cohen is elected president of the McGill Debating Union.

1955: He completes his exams at age 20, but he has no career plans. The thought of taking over the family business does not appeal to him. He is infatuated with music and writing.

1956: Cohen is 22 when *Let Us Compare Mythologies* is published as the first volume of the McGill Poetry Series. The book contains 44 poems written between 1949 and 1954. Cohen recites eight of the poems, alongside Louis Dudek, Irving Layton, et al, on the LP *Six Montreal Poets*, which was recorded by the CBC in 1956. The liner notes describe Cohen as "a new important name to readers of Canadian poetry."

In the fall of that same year, he enrolls in general studies at Columbia University in New York. He takes a liking to the aesthetics of the early Beat poets.

1957: Back in Montreal, he continues writing. He gives his first professional poetry reading at Dunn's Birdland. This is followed by appearances in well-known coffee houses. Following the example of Jack Kerouac, he sometimes reads to the accompaniment of jazz music; sometimes he accompanies himself on the guitar. In July he completes the first draft of his novel, *A Ballet for Lepers*, which remains unpublished to this day.

April 1959: He receives a scholarship from the Canada Council ($2,000) and flies to London in December. There he writes a first draft of his novel *Beauty at Close Quarters* in just three short months.

March 1960: He travels to Hydra via Jerusalem and soon comes into contact with the local bohemian and artist scene. During the summer his daily routine consists

of working, swimming in the ocean, and getting together with friends in the harbor café. On **27 September** he buys a simple three-storey, 200-year-old house on the island for $1,500 with money he inherited from his grandmother. He lives there together with Norwegian Marianne Jensen and her son, whom he had met shortly after his arrival.

October 1960: The couple travels overland together to Oslo in order to attend the court date for Marianne's divorce. Cohen flies to Montreal in **November** in order to scrape together some money.

The novel he wrote in London fails to find favor with publisher McClelland, but his volume of poetry *The Spice-Box of Earth* is published in **1961**, and Leonard is well-pleased with the finished product. He receives positive reviews.

Another stipend from the Canada Council ($1,000) and income from an inheritance enable him to continue his life on Hydra. From **1961 - 1962** Cohen redacts poems and his novel *Beauty at Close Quarters*, which is published as *The Favourite Game* in **September 1963**, initially by Secker in London and later by Viking in New York; McClelland & Stewart had rejected it.

1964: Cohen is awarded the Quebec Literary Competition Prize for the novel. Michael Ondaatje, also an author with McClelland & Stewart, praises his style and compares it with James Joyce's *Portrait of the Artist as a Young Man*.

Leonard must constantly return to Montreal in order to seek out sources of money. He is unsuccessful in selling the film rights for *The Favourite Game* (40 years will pass before it is brought to the screen by Bernar Hébert); he does succeed, however, in selling his archive of manuscripts to Marion E. Brown, head of the Thomas Fisher Rare Book Library at the University of Toronto. His next collection of poems, *Flowers for Hitler*, is published by McClelland in **1964**, even though he is not under contract.

Winter 1963: Cohen meets the 17-year-old dancer Suzanne Verdal in Montreal. He dedicates the poem "Suzanne" to her in *Parasites of Heaven*, which is published in 1966. It is later set to music and goes on to become one of Cohen's most famous songs; by then, however, he had lost the rights to it.

October 1964: A reading tour with Cohen, Layton, and two other poets is recorded by the Canadian National Film Board. It provides the material for a documentary, the final version of which revolves solely around Leonard: "Ladies and Gentlemen, Mister Leonard Cohen."

1965: Cohen writes the novel *Beautiful Losers* on Hydra while under the influence of sundry drugs, totally exhausting himself creatively and physically. Upon its completion, Cohen fasts for ten days, collapses, and must be taken to a hospital.

Beautiful Losers causes a scandal, but it doesn't put any money in his bank account. Realizing that writing is not a reliable source of income, he decides at some point in **1966** (his biographers disagree as to the exact chronology) to earn his money with music. That same year he meets Judy Collins in New York. She covers two of his songs for her album and arranges a live gig for him. During his extended stays in New York in **1966 and 1967** he also gets to know Andy Warhol and his entourage and uses them as a source of inspiration for his lyrics and songs.

22 February 1967: Cohen has his official live debut as a singer in New York with 3,000 people in attendance. Nervousness causes his voice to fail, and he breaks off, but the audience cheers when he gives it a second try.

Again thanks to Collins, his first recording contract ensues: the recording sessions for *Songs of Leonard Cohen* take place between **May and November 1967**.

That same summer he performs at several festivals, including the Newport Folk Festival on **16 July**.

The album hits the shelves in late **December 1967**. The reaction of the American press is initially muted; as a songwriter, however, he is mentioned in the same breath with Bob Dylan due to the poetic quality of his lyrics. The

resonance in Great Britain is more positive from the outset; his album makes the Top 20.

Summer 1968: His volume of poetry *Selected Poems* is published. In the wake of Cohen's growing popularity as a musician, it rapidly becomes a bestseller, selling 200,000 copies in just three months. *Selected Poems* earns Cohen a nomination for the Governor General's Award, but he declines.

Between **September and November 1968**, he records *Songs from a Room* with producer Bob Johnston in Nashville.

The album appears in stores in **April 1969** and sells better than the first; it reaches number 12 on the charts in Canada, number 63 in the US, and number 2 in Great Britain.

Cohen rents a farm from Bob Johnston 36 miles south of Nashville, enjoying the solitude of country life, replete with horses and guns, to compose further albums. He is separated from Marianne at this point in time; the new woman at his side is 19-year-old Suzanne Elrod, whom he met while dabbling in Scientology. He also makes the acquaintance of Joshu Sasaki Roshi, who will later become his Zen master and friend.

May 1970: His first European tour, with nine concerts in eight cities in two weeks. It kicks off in Hamburg; performances in Vienna, Amsterdam, Paris, and London follow. Tickets for the concert in London's Albert Hall are sold-out within 30 minutes. That summer, Cohen and band play festivals at Aix-en-Provence and on the Isle of Wight.

September 1970: Recording commences for his third album, *Songs of Love and Hate,* in Nashville. Released in **March 1971**, it is a hit in Great Britain (number 5 on the charts), a flop in the US (not even making the Top 100), and reaches number 24 in Germany. The University of Halifax awards Leonard an honorary Ph.D. the same month the album is released.

Music from *Songs Of Leonard Cohen* is used on the soundtrack for Robert Altman's movie *McCabe and Mrs.*

Miller, which is released in the summer of 1970. "Sisters of Mercy" and five other songs find their way into the soundtrack of Rainer Werner Fassbinder's *Beware of a Holy Whore* (1970/71). Werner Herzog incorporates one song into *Fata Morgana* (1971).

Despite his success as a songwriter, Cohen continues to write poetry and prose. *The Energy Of Slaves* is published in **1972**.

Columbia presses him for another European tour (23 cities in 40 days, the last of which are in Israel). After rehearsing in Nashville, the tour kicks off in **March 1972** in Dublin, and is captured on film in its entirety by Tony Palmer.

18 September 1972: Adam Cohen, Leonard's first child with Suzanne Elrod, is born in Montreal. Shortly thereafter, Leonard visits the Mount Baldy Zen Center for the first time and spends a week there.

April 1973: His fourth album, *Live Songs*, is released. Nine of the songs were written during the two tours. One of them, "Queen Victoria," was recorded on a borrowed tape deck in the cabin of his farm in Tennessee.

Summer 1973: Cohen is back on Hydra. When the Yom Kippur War breaks out in **October**, he travels to Israel with the intention of joining the Israeli army. He wants to serve in various units, but is instead given an assignment entertaining troops.

August 1974: The album *New Skin for the Old Ceremony* is released. A new producer, John Lissauer, gives him a new sound, one that is designed "to take him out of the folk world." With the exception of Great Britain and Germany, sales are unremarkable.

September 1974: Birth of his second child, daughter Lorca. That same month, kick-off of his next European tour with 33 concerts in 50 days. "In Europe Leonard was bigger than Dylan – all the shows were sold out … women outnumbered men three to one in the audiences". A tour of the US follows, but it turns out that he is "almost unknown" there.

November 1975: *The Best of Leonard Cohen* is released;

the European version is titled *Greatest Hits*. Leonard compiled the songs and wrote the cover notes.

April – July 1976: The next European tour – 55 concerts in 78 days between Berlin and London. In addition to other unreleased material, he also plays "Die Gedanken sind frei" during this tour.

1976: Marty Machat arranges a joint-project with Phil Spector. The upshot is the album *Death Of A Ladies' Man*, which is recorded in Los Angeles in **1977** and goes on sale in **November**. Cohen distances himself from the record because Spector had chosen the final version of the recordings, rather than he. Despite the marked change in sound, the public echo is much the same as with the earlier albums: it is successful in Europe, but doesn't make the US charts.

February 1978: Death of his mother, Masha Cohen. His book *Death Of A Ladies' Man* is released in the fall and is dedicated to her.

1979: Legal separation from Suzanne, whom he had never married. Suzanne moves with the children to southern France, and he frequently visits them there.

Following *Death of a Ladies' Man* he immediately begins work on a new album. Cohen moves to Los Angeles in order to spend as much time as possible with Roshi at Mount Baldy.

September 1979: The release of *Recent Songs*, which receives panegyric reviews. The *New York Times* counts it among the best ten albums of the year. Sales, however, lag behind all previous albums.

A tour of Europe kicks off in **October** with 51 concerts. Sharon Robinson is on board for the first time; musically she will become an important partner for Cohen in the years to come, and she accompanies him on all his tours until 2013. Roshi also travels with them in the tour bus, and filmmaker Harry Rasky shoots a documentary about the tour for the CBC, *Songs Of Leonard Cohen*, which is shown on Canadian television in **1980**. Henry Lewy also records a live album, later titled *Field Commander Cohen*, but Columbia doesn't release it until 2000.

October 1980: Another five-week European tour follows, which winds down in Israel. Cohen writes new material during the tour in collaboration with Sharon Robinson.

Late 1980: Cohen decides to withdraw from the music business for an indefinite period of time. He wants to spend time with his children, who are still in southern France.

Early 1982: During a stay on Hydra, mutual friends bring French photographer Dominique Issermann along to the island – the two fall in love. Cohen is working on a book, and he writes and stars in the CBC made-for-TV musical film *I am a Hotel*, which features five of his songs and is awarded a Golden Rose at the Montreux TV festival in **1984**.

April 1984: *Book of Mercy* is published. He receives the Canadian Authors Association Literary Award for Poetry. That same year, Cohen records the album *Various Positions*. Columbia releases it internationally – except in the US, where it is released a year later, in **1985**, on the Passport label.

31 January – 24 March 1985: The "Various Positions Tour" swings through Europe and is a great success. It is later followed by concerts in Australia and on the US West Coast as well as 15 additional concerts in Europe, culminating in Jerusalem in mid-summer.

Jennifer Warnes, former backup vocalist on the 1979 tour, launches a solo career and records an album featuring nine Cohen songs on an independent label titled *Famous Blue Raincoat*. It is released in **1987** and sells 750,000 copies in the US! In early 1986, and supposedly for the sake of his teenage children, Cohen makes a guest appearance on the '80s TV crime series *Miami Vice*, which often features notable celebrities. He plays a French Interpol agent.

His career thus appears to be on the upswing, but it is punctuated time and again by emotional breakdowns, separations (from Dominique Issermann), and phases of retreat in the monastery.

A new Album, *I'm Your Man*, is released in **1988**, first in Europe, later in the US and Canada. According to Simmons, "The album was a success – Leonard's biggest since the early seventies and biggest in America since his debut," and it also "rebranded Leonard, not least among younger fans, from dark, tortured poet to officially cool."

The critics are ecstatic. A promo-tour through Europe kicks off on **7 February 1988**; the actual tour follows in **April 1988**. He must find a new manager, however, because Marty Machat passes away in March. Machat's secretary and assistant, Kelley Lynch, fills the gap, becoming, by turns, Cohen's girlfriend and manager: "Lynch took various files on Leonard from the offices of Machat & Machat that the lawyers said could be taken legally, including documents relating to the publishing company that Marty Machat had set up for Leonard."

The *I'm Your Man* tour kicks off in Germany and entails 59 concerts in three months. His tour of the US from July to November goes very well. The album sales exceed all previous albums. His success is accompanied by a new love in the person of Rebecca De Mornay, an actress thirty years his junior, whom Cohen would nearly marry.

1990: His eighteen-year-old son Adam is involved in a serious automobile accident. Cohen discontinues working on songs for his next album and spends four months with his son during his hospital stay.

June 1991: He is inducted into the Canadian Music Hall of Fame. In **October** he is appointed Officer of the Order of Canada, the country's second-highest honor for merit. In **November** a tribute album is released titled *I'm Your Fan*, which features 18 Cohen songs.

1992: Following a four-year pause, Leonard's next album, *The Future*, is released. It is highly praised by critics and the public; three songs appear on the soundtrack of Oliver Stone's *Natural Born Killers*.

March 1993: *Stranger Music: Selected Poems And Songs* is released, a 400-page anthology of his lyric work. Sales proceed well, because many of the original editions of the chapbooks are out of print.

April – July 1993: The *Future* tour is underway. It kicks off in Scandinavia and spans 63 concerts. Success in the US is no longer an issue: audiences and critics lionize the master. Eight songs, including five from the 1988 tour, appear on the live CD *Cohen Live* in **1994**.

Also in 1993, Cohen receives the Governor General's Performing Arts Award for Lifetime Artistic Achievement. Nevertheless, he once again turns his back on success in the public limelight as well as in private life at the side of Rebecca De Mornay and goes into seclusion at the monastery. This time the decision appears to be final. Aside from a few short excursions to Los Angeles, Leonard Cohen remains at Mount Baldy for five years. He tells his former producer Roscoe Beck that he has "had it with this music racket." The last tour had been excruciating for him. He drank heavily in order to overcome stage fright and fears of failure. He also wishes to spend some time with his friend Roshi, who is approaching 90.

September 1994: *Take This Waltz* is published on the occasion of Cohen's 60th birthday. The book was compiled for him by writers and artist friends.

September 1995: At the instigation of Leonard's manager Kelley Lynch, the tribute album *Tower of Song* is released, on which Elton John, Billy Joel, Tori Amos, Sting, and other music greats pay their homage.

1995: The website "Leonard Cohen Files" is founded by a Finnish fan; Cohen enriches it with contributions of his own.

9 August 1996: After three years in the monastery, Cohen is ordained as a Buddhist monk at Roshi's suggestion. He is given the name Jikan, "Silence."

Adam Cohen signs a record contract with Columbia that same year and visits his father, seeking his advice.

Two film teams, one French and one Swedish, shoot documentaries about Leonard's monastic life. Asked during an interview if he will ever make music again, he answers "No."

1997: In celebration of 30 years of collaboration, Columbia releases *More Best of Leonard Cohen*; Leonard personally compiles the tracks.

January 1999: Plagued by deep depression, he flees the monastery in order to travel to India, where he seeks alleviation from a new master, 81-year-old Hindu teacher Ramesh S. Balsekar, in Mumbai. Altogether, he spends a year – with interruptions – under the guidance of his new teacher. Then, with 250 songs and poems in his pocket, he returns to the music business.

February 2000: *Field Commander Cohen* is released, an album comprised of twelve songs recorded during the 1979 tour.

October 2001: Release of the album *Ten New Songs,* which he dedicates to Roshi. It is a complete success in Europe and Canada, but sales in the US are again poor.

2002 and 2003: Release of two albums: *The Essential Leonard Cohen* and *An Introduction to Leonard Cohen.*

June 2003: Numerous artists stage a tribute concert in Brooklyn: "Came so far for Beauty: An Evening of Songs by Leonard Cohen under the Stars." It is a consolation for fans because Leonard does not want to go on tour with the new album.

Instead, he works on *Book of Longing* and his next studio album. *Dear Heather* is released in **October 2004.**

That same month, news reaches him that his manager, Kelley Lynch, had embezzled his entire fortune, amounting to between 10 and 13 million dollars. After protracted legal proceedings, she receives a jail sentence. Cohen is faced with the problem of refinancing his retirement.

August 2005: Canadian television airs *This Beggar's Description,* in which Leonard talks with an impoverished poet on a park bench.

Together with his current romantic companion Anjani Thomas, he collaborates on the album *Blue Alert,* which is released under her name in **2006.**

The tribute concerts, which originated in Brooklyn, have since developed a life of their own and are held annually all over the world. A movie is made about them, *Leonard Cohen: I'm Your Man,* which is shown at the Toronto Festival in **2005** and runs in art houses in the US in the fall of **2006.**

May 2006: *Book of Longing* is published. It is his first book of poetry in 22 years, and it is illustrated with an equal number of drawings.

February 2007: Adam Cohen makes Leonard a grandfather: birth of grandson Cassius Lyon.

Philip Glass and Cohen collaborate on "Book of Longing: A Song Cycle based on the Poetry and Images of Leonard Cohen," a stage production that has its world premiere in Toronto on **1 June 2007.** It coincides with a traveling exhibition of drawings and sketches titled *Drawn To Words.*

March 2008: Cohen is inducted into the Rock and Roll Hall of Fame.

May 2008: Kickoff of the "World-Tour." Leonard is reluctant to go on tour, afraid that he will play to half-empty venues after being absent from the stage for so long. He sees no other way to refill his coffers, however, and his efforts are rewarded.

Following a few dry runs in small towns on Canada's east coast, the tour officially gets underway in **June** in Toronto. Divided into three legs, the World Tour runs **until December 2010** and spans all continents. Due to its great success, it is extended time and again.

March 2009: Release of the CD and DVD *Live in London* recorded at the O2 Arena in London on 17 July 2008. Riding the wave of its success, the concert recording of the 1970 Isle of Wight Festival, *Live at the Isle Of Wight,* immediately follows; and more recordings from the ongoing tour are released as CD/DVD combo in **2010:** *Songs from the Road,* which includes recordings made in 2008 and 2009. This is accompanied by an unauthorized rerelease of his first albums until Cohen intervenes with his label.

18 September 2008: Cohen collapses on stage during a concert in Valencia while singing "Bird on a Wire." After recovering from suspected food poisoning, he is back in the tour bus two days later.

In total, the tour grosses over 50 million dollars. Even after the deduction of all expenses, Cohen is financially

better off than he was before the embezzlement. Apart from the financial security, he now finds that he immensely enjoys life on tour, which had once been excruciating for him.

While still on tour, he had expanded the program bit by bit to include new songs. Now he goes into the studio to record them … with the intention of going on tour again!

February 2011: Birth of his second grandchild, Viva Katherine Wainwright Cohen.

That same year, he is awarded the Glenn Gould Prize for lifetime achievement as well as with Prince of Asturias Award for Literature, which he accepts with a much-applauded, highly-polished speech of thanks.

January 2012: His new album, *Old Ideas*, is released and takes the international charts by storm. From August onward, Leonard is on tour again, starting as usual in Europe. The five-leg tour runs until **December 2013**, and he performs all over the globe.

Leonard Cohen celebrates his 80th birthday on **21 September 2014**. Rumor has it that he is working on a new album, and that he still intends to tour at 80.

Discography

Songs Of Leonard Cohen, 12/27/1967
Songs From A Room, 4/7/1969
Songs Of Love And Hate, 3/19/1971
Live Songs, 4/1/1973
New Skin For The Old Ceremony, 8/11/1974
The Best Of Leonard Cohen, 1/1/1975
Death Of A Ladies' Man, 11/13/1977
Recent Songs, 9/27/1979
Various Positions, 12/11/1984
I'm Your Man, 2/2/1988
The Future, 11/24/1992

Cohen Live/Leonard Cohen in Concert, 6/28/1994
More Best Of, 10/7/1997
Field Commander Cohen: Tour of 1979, 2/20/2001
Ten New Songs, 10/9/2001
The Essential Leonard Cohen, 10/22/2002
Dear Heather, 10/26/2004
Live in London, 3/31/2009
Leonard Cohen Live At The Isle Of Wight, 10/20/2009
Songs From The Road, 9/14/2010
Old Ideas, 1/31/2012

Tours

First European Tour: May 1970. Hamburg, Frankfurt, Munich, Vienna, London, Paris

Second European Tour: March – April 1972. 21 concerts, ending in Jerusalem and Tel Aviv

Third European Tour: September – October 1974. 33 concerts in 50 days in Belgium, France, Great Britain, Germany, the Netherlands, Austria, and Spain

Fourth European Tour: April – July 1976. 55 concerts in 78 days, of which 16 are in Germany, 14 in Great Britain as well as in Scandinavia, the Benelux, Austria, Switzerland, and in France

The Smokey Life Tour: October – December 1979 in Europe; March 1980 Australia, Bread & Roses Festival in Berkeley, California; autumn 1980 again in Europe; final concert on 24 November 1980 in Tel Aviv; 89 concerts in total

Various Positions Tour: 31 January 1985 (Mannheim) – 21 July 1985 (St. Jean de Luz, France). 74 concerts on four continents

I'm Your Man Tour: 5 January – 16 November 1988. 81 concerts in Europe and North America

The Future World Tour: 25 April – 30 July 1993. Europe and North America; a total of 63 concerts

Leonard Cohen Tour: 14 June 2008 – 11 December 2010. 256 concerts in North America, Europe, Oceania, and the Middle East

Old Ideas World Tour: 12 August 2012 – 21 Dezember 2013. 125 concerts in Europe, North America, Oceania

Poems and Prose

Let Us Compare Mythologies, Contact Press (McGill Poetry Series No. 1), Toronto 1956; Reprint: McClelland and Stewart, Toronto, 1966

The Spice Box Of Earth, McClelland and Stewart, Toronto 1961

The Favourite Game (novel), First edition by Viking Press, New York 1963, and Secker and Warburg, London 1963, Paperback by McClelland and Stewart 1970

Flowers For Hitler, McClelland and Stewart, Toronto 1964

Beautiful Losers (novel), McClelland and Stewart, Toronto 1966

Parasites Of Heaven, McClelland and Stewart, Toronto/Montreal 1966

Selected Poems 1956–1968, McClelland and Stewart, Toronto/Montreal 1968

The Energy Of Slaves, McClelland and Stewart, Toronto 1972

Death Of A Ladies' Man, McClelland and Stewart, Toronto/Montreal 1978

Book Of Mercy, McClelland and Stewart, Toronto/Montreal 1984

Stranger Music – Selected Poems And Songs, Jonathan Cape, London 1993

Book Of Longing, McClelland and Stewart Ltd., Toronto 2006; HarperCollins, New York 2006

Poems and Songs, Everyman's Library, Pocket Poets, Random House, New York 2011

Fifteen Poems, Everyman's Library, Pocket Poets, Random House, New York 2012 (E-Book)

Bibliography

Devlin, Jim (ed.): *Leonard Cohen – In His Own Words*, Omnibus Press, London 1998

Hesthamar, Kari: *So long, Marianne,* translated by Helle V. Goldman, ECW Press, Toronto, 2014

Graf, Christof: *Leonard Cohen. Titan der Worte*, Edel, Hamburg 2010

Nadel, Ira B.: *Leonard Cohen – A Life In Art*, ECW Press, Toronto 1994

Ondaatje, Michael: *Leonard Cohen*, McClelland and Stewart, Toronto 1970

Simmons, Sylvie: *I'm Your Man. The Life Of Leonard Cohen*, Ecco, HarperCollins, New York 2012

Picture Credits

We thank Marianne Ihlen for her kind permission to publish her photograph on page 44.

p. 22/23: Allan R. Leishman/Montreal Star/Library and Archives Canada; p. 24, 25: Allan Blackham/Montreal Star/Library and Archives Canada; p. 28: © NFB of Canada; p. 29, 30/31, 33, 35, 37, 38/39, 40/41, 43: James Burke/Time & Life Pictures/Getty Images; p. 46, 47, 48/49, 50/51, 52/53: David Gahr/Getty Images; p. 55: Schirmer/Mosel Archive; p. 57: © Condé Nast Archive/ Corbis; p. 58/59: akg-images / Tony Vaccaro; p. 61: Roz Kelly/ Michael Ochs Archives/Getty Images; p. 63: Michael Ochs Archives/Getty Images; p. 64/65, 80/81: Michael Putland/Getty Images; p. 66, 68, 69: Interfoto/Hug; p. 67: Gus Stewart/ Redferns; p. 71, 72/73: Gijsbert Hanekroot/Redferns; p. 75: Hans-Jürgen Dibbert – K & K/Redferns; p. 76: © Guy Le Querrec/Magnum Photos; p. 77 and cover: Ian Cook/Time Life Pictures/Getty Images; p. 78, 79: Tom Hill/WireImage; p. 83: Terry Lott/Sony Music Archive/Getty Images; p. 85, 87, 89: © David Boswell; p. 93: © Thierry Orban/Sygma/ Corbis; p. 94/95: Tom Sheehan/Sony Music Archive/Getty Images; p. 97, 98, 99: Oliver Morris/Getty Images; p. 100/101: © Frédéric Huijbregts/ Corbis; p. 102/103, 105: © Eric Preau/Sygma/Corbis; p. 106/107: © Bernard Barbereau/Sygma/Corbis; p. 108: © Deborah Fein-gold/Corbis; p. 109, 111, 115: Rob Verhorst/Redferns; p. 117, 118, 119, 120: © Neal Preston/Corbis; p. 121: © Gary Moss/Corbis Outline; p. 125: Ethan Hill/Contour by Getty Images; p. 127: Mitch Jenkins/Contour by Getty Images; p. 129: Kevin Kane/ WireImage; p. 130/131: © Luke MacGregor/Reuters/Corbis; p. 132/133: © Rune Hellestad/Corbis; p. 135: Ben Stansall/AFP/ Getty Images; p. 136/137, 138/139: © 2014 Sibylle Nottebohm; p. 141: Carlos R. Alvarez/WireImage; p. 143: © Jack Abuin/ ZUMA Press/Corbis; p. 144: Michael Loccisano/Getty Images; p. 145: Nicolas Maeterlinck/AFP/Getty Images; p. 146/147: © Alex Sturrock/Corbis Outline; p. 148: Thomas Samson/AFP/ Getty Images; p. 149: Gary Miller/FilmMagic; p. 150: David Wolff-Patrick/Redferns via Getty Images; p. 151 and back cover: Tim Mosenfelder/Getty Images

Captions to the plates and editing of the appendix:
Michaela Angermair

Translated from the German by Roger W. Benner

© 2014 by Schirmer/Mosel Munich

Lithography: Bayermedia, Munich
Printing and binding: EBS, Verona

ISBN 978-3-8296-0664-6

A Schirmer/Mosel Production
www.schirmer-mosel.com